Brush with
ACRYLICS

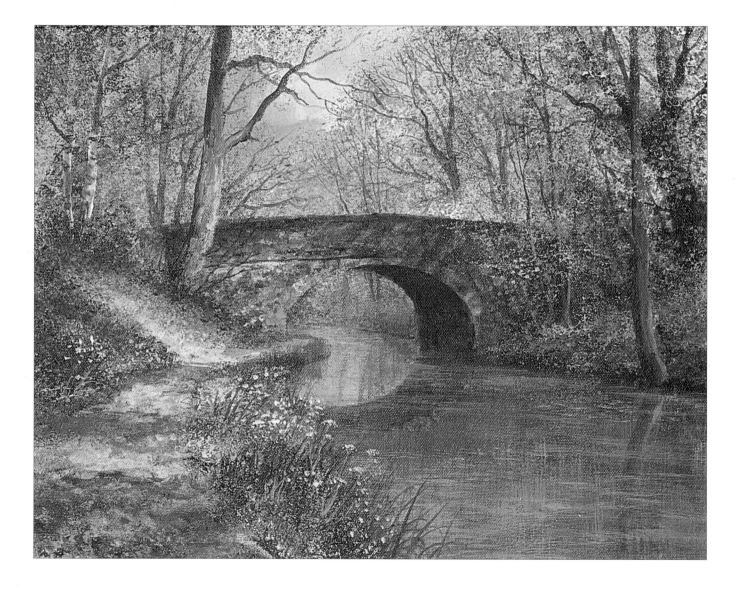

*To my wife, Kate,
and my daughters
Amy and Lucy*

Brush with
ACRYLICS
Painting the easy way

TERRY HARRISON

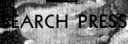

Search Press

First published in Great Britain 2004

Search Press Limited
Wellwood, North Farm Road,
Tunbridge Wells, Kent TN2 3DR

Reprinted 2004, 2005, 2006, 2007 (twice), 2008 (twice)

Text copyright © Terry Harrison 2004

Photographs by Charlotte de la Bédoyère,
Search Press Studios
Photographs and design copyright © Search Press Ltd.
2004

ISBN: 978 1 84448 008 1

The Publishers and author can accept no responsibility for
any consequences arising from the information, advice or
instructions given in this publication.

Suppliers
If you have any difficulty obtaining any of the materials
and equipment mentioned in this book, please contact
Terry Harrison at:

Telephone: +44 (0)1386 584840

Website: www.terryharrisonart.com

Publishers' note
All the step-by-step photographs in this book feature
the author, Terry Harrison, demonstrating how to
paint with acrylics. No models have been used.

*Thanks to my wife's brother and sister, Derek and
Judy Whicher, who help me to run my gallery
and office, and to my framer and assistant
Daniel Conway, who is an artist in his own
right.*
*Thanks also to my editor Alison Howard for
helping me find the right words to write this
book. Doing so brought back fond memories of
Mrs Riley, who owned the local art shop when
I was a penniless student. She helped me to learn
how to paint in acrylics by giving me lots of
samples I couldn't possibly have afforded to buy!*

Printed in Malaysia

Cover: Summer Meadow
Page 1 Spring Reflections
Pages 2/3 Christmas Post
Page 4 French Lane
Opposite The Souvenir Shop

Contents

INTRODUCTION

Art is my job, but it is also a constant pleasure that I like to share with others. I spend a lot of my time travelling and giving demonstrations both at home and abroad. My aim is to help to make art accessible, so as many people as possible can share the joy it has brought me over the years. It also helps me to find out what people really want to know about painting, which is how my first book, *Brush with Watercolour*, came about. Since its publication, increasing numbers of people tell me they would also like to know how to use acrylics, but need some help to get started. I decided to do my best!

I like acrylic paints, and I have been using them since I first went to art school at the age of sixteen. When you know how to use them, they are really easy and incredibly versatile. They can be used to produce so many effects, from the style of watercolour to the authentic look of an oil painting, with a huge range of effects and possible variations in between. Acrylics allow you to add layers of paint and texture in a way that would be impossible with watercolours. Used like watercolour, they dry at the same rate, but if you want more time to get things right you can add retarder to slow the drying process. When you use them like oil paint the results are remarkably similar, but without the smell or the long-winded drying process. The possibilities are almost endless. I hope to give you a taste of some of them, and the desire to develop your own ways of using acrylics.

The inspiration for the paintings in this book comes, as ever, from what I see around me. My main interest is the traditional landscape, and my constant travelling means that I am never short of inspiration. The changing seasons and the influence of weather means that there is always a fresh point of view, even when I go back to places I have seen many times before. I hope that this book will give you the confidence to go out and capture what you see around you, and that this will give you as much pleasure as it gives me.

Opposite
The Short Cut
I painted this very quickly on heavily-textured canvas. There is very little foreground detail, but I spent time and care on the focal point, the church.

Pages 8–9
Willy Lott's Cottage
I am not the first person to paint this cottage in Suffolk, and I certainly won't be the last! It is near Flatford Mill where the landscape artist John Constable used to paint, and features in his painting The Haywain.

6

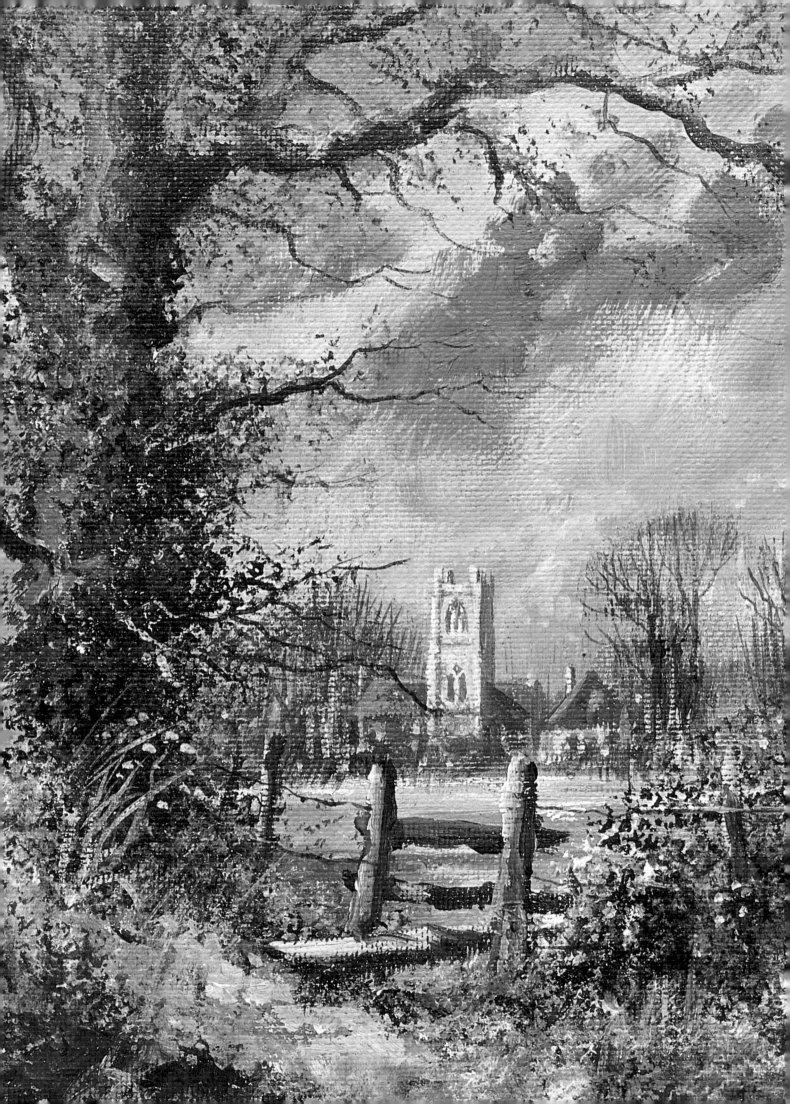

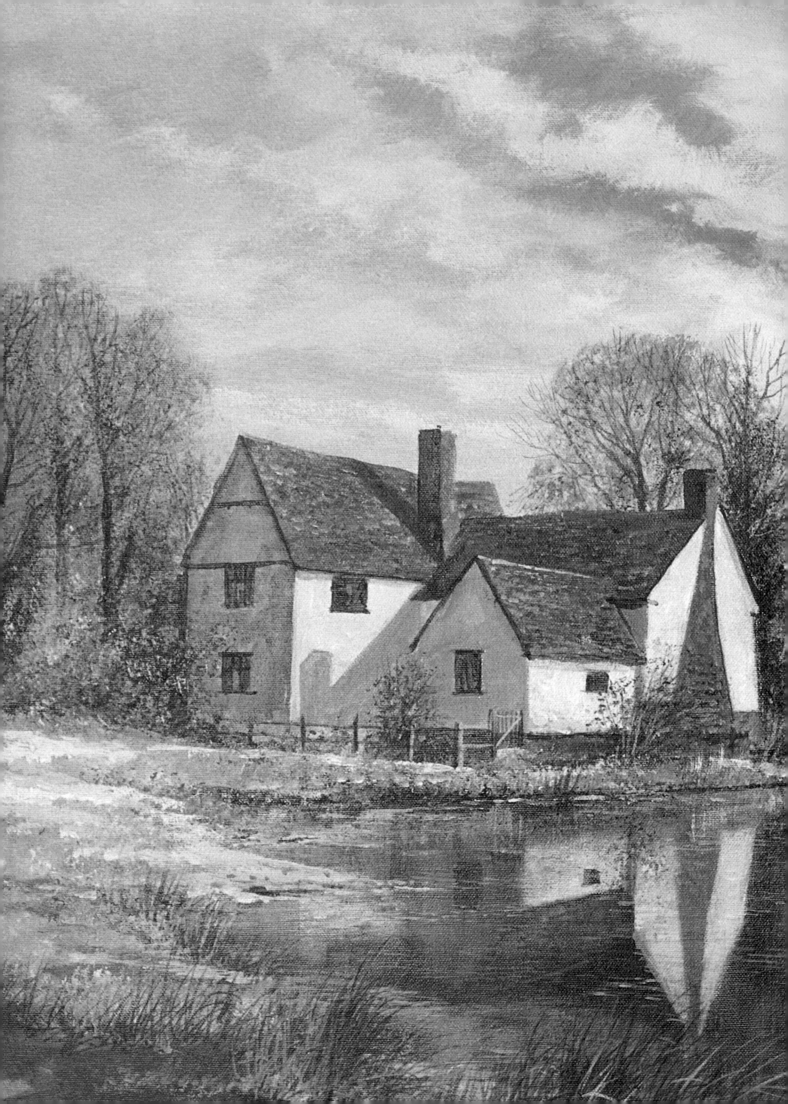

CHOOSING YOUR EQUIPMENT

Materials

Paper
Acrylics can be used with many different kinds, but I always choose paper with some texture. I generally choose 300gsm (140lb) rough watercolour paper as it adds interest to the paintings. If I use paper that is too smooth, the paint seems to slide off the surface.

Canvases
You can spend a lot of money on linen canvas, but I really do not see the point. I usually use a medium grain canvas made from cotton or a cotton and synthetic blend, and I find the results are just as good.

Boards
Textured board is a cheaper option than canvas. I usually choose medium or heavy texture. I also use canvas board, which costs far less than canvas but gives a similar effect.

Sketch book
I always carry a sketch book wherever I go.

Ruler
I use this with a scalpel for cutting paper or board, and as a useful guide when I am putting in straight lines with the half-rigger.

Canvases, board and paper and sketch book

Disposable palette
These tear-off coated paper sheets are shaped like a traditional palette.

Masking tape
I use masking tape to attach my paper to the drawing board. Never try to use ordinary sticky tape – it just does not work.

Palette knife
Painting knives come in many shapes and sizes – experiment until you find one you like. Strictly speaking, painting knives are shaped like trowels and palette knives are like flexible spatulas, but I never bother to make a distinction. My favourite is triangular, about 38mm (1½ in) long and 25mm (1in) wide.

Ruling pen
I use this with masking fluid to draw in fine lines for grasses.

Pencil
Use this to sketch preliminary outlines, or to draw on top of the first wash, as acrylic paint tends to cover up pencil lines.

Scalpel
I use a scalpel with a standard blade for trimming paper, as I have done since I first worked in a graphics studio.

Eraser
I use a hard eraser to remove masking fluid and to correct mistakes, as a putty eraser can sometimes smudge.

Soap
Coating brushes with soap before using them for masking fluid makes it easier to remove.

Absorbent paper
I use this to dry brushes (not shown).

Tip
I am too impatient to stretch paper before I use it. If a painting cockles, I turn it face down on a smooth, clean surface and wipe all over the back with a damp cloth. Then I put a drawing board over it, weigh it down and leave it to dry. The cockling disappears as if by magic!

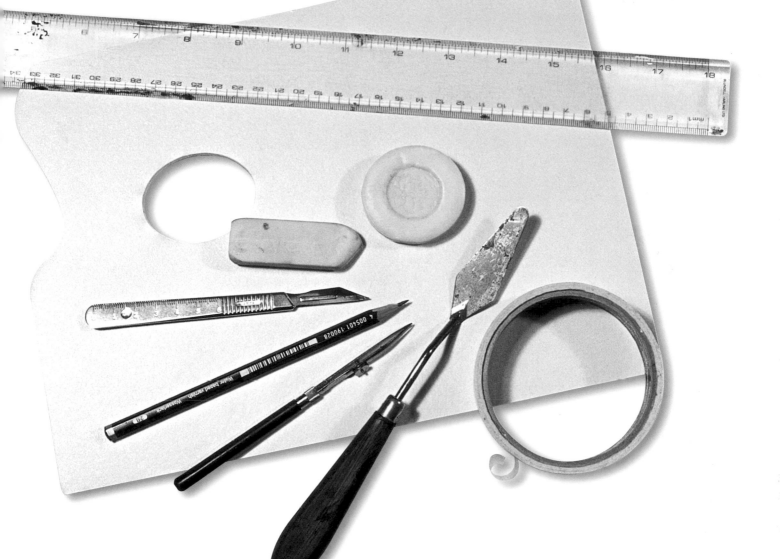

Bucket

This is one of the most important items on my materials list. Acrylic has a reputation for ruining brushes, but this only happens when paint is left in the brush. Brushes should be rinsed properly if you want them to last, and for that you need lots of water. Small jars of water are just not good enough! I use a large plastic bucket in my studio, but when I demonstrate I take my 'travelling bucket' – a five-litre (eight pint) size.

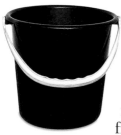

Stretchers

The wooden frame for a canvas (right) is called a stretcher bar. It is not joined, it is pushed together and held in place when the canvas is stapled on. Small wooden wedges are placed in the corner slots and hammered in. This forces the corners of the stretcher bar apart and stretches the canvas.

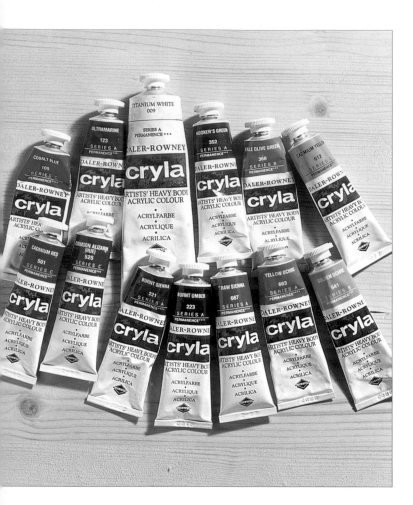

Paints

Choosing acrylic paints is a bit of a minefield because there are so many different ranges available. One of the main differences is in the consistency: some are heavy body i.e. thicker, some are thinner flow formula. The choice is largely down to the style of painting you want to do. If you want to paint in the style of oils, a heavy body formula is best, but for detailed or design work you should choose a more free-flowing formula. You really do have to experiment to find the paint that works for you in a particular situation. Don't forget that you can always water down a paint that is too thick. If you find a good art shop they should be able to advise you.

Make sure you always put the lids back on the tubes of paint to stop them drying out. If you have left a tube for a while and have trouble getting the top off, a good tip is to dip the cap in hot water to free the paint. If all else fails and you are tempted to resort to pliers, don't – they don't work very well. If one of my lids is well and truly stuck I use a pair of nutcrackers to ease it off!

Mediums

Glaze

Glaze straight from the tube looks white. Do not let this put you off – it dries clear. Using glaze over a painting is like applying a wash of colour. When you mix in colour it is suspended in the glaze medium, which acts like a piece of tinted glass. Light travels through the glaze, hits the colour on the painting and is reflected back, giving a fresher, cleaner effect than using solid colour.

Retarder

This slows down the drying time, giving you more time to work.

Texture paste

This is a thick, textured paste that you apply to the surface of your work to create textured effects. It is left to dry, then colour is applied on top. Acrylics are flexible, so you can do this without the risk of the paint cracking.

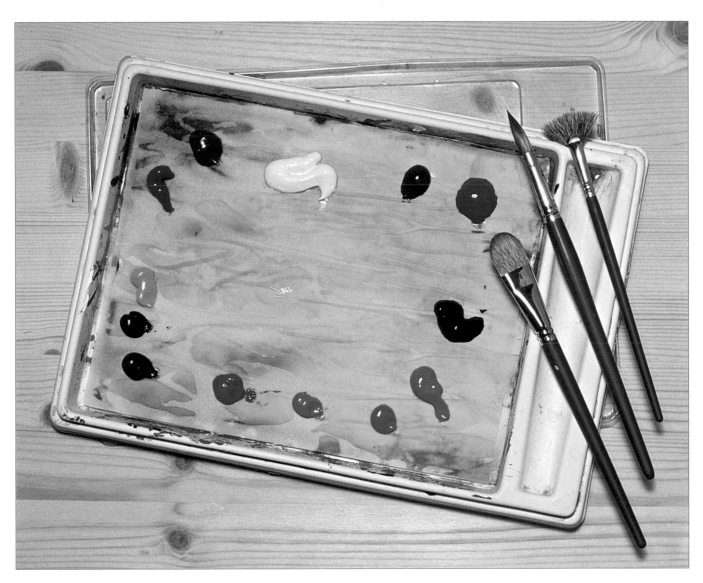

Heavy body medium

If you are using a fairly liquid type of paint, but you want to use thicker paint to build up textures, adding heavy body medium will 'beef it up'. Impasto medium produces a similar result.

Flow enhancer

This helps to improve the flow of the paint from the brush.

Masking fluid

Not all artists approve of masking fluid, but I think it is essential! It is simple to use and extremely effective. I coat my brush with soap before dipping it into the masking fluid so that it rinses out easily. This means that I can use quite good-quality brushes for masking fluid without damaging them.

Palette

This useful item is designed to keep paint wet and workable for weeks, and is available from most good art shops. It uses disposable sheets that sit on blotting paper or absorbent fibres over a reservoir of water. Choose a size you like and do not forget to replace the lid, which will stop the moisture evaporating. In hot weather the palette can go mouldy and start to smell. Use distilled water or add ordinary household antiseptic to help to keep it fresh.

Varnish

I use acrylic varnish (not shown) to protect the surface of finished paintings on canvas, board and other non-porous surfaces. It is available in gloss or matt finish. I do not use varnish for paintings on watercolour paper as I frame and mount them behind glass.

Basic colours

ultramarine

cobalt blue

alizarin crimson

cadmium red

cadmium yellow

burnt umber

burnt sienna

raw sienna

yellow ochre

Hooker's green

pale olive green

Extra colours

golden ochre

permanent rose

My palette

I am not a great believer in the limited palette because I love to use lots of colour. When I am working with acrylic paints, just as when I paint in watercolour, I use a basic palette of eleven colours plus white. These are shown left, but they should be regarded only as a useful starting point. I also have lots of colours that were bought just because I liked them, or because I thought a painting needed a particular colour. I don't think there is anything wrong with that! Golden ochre and permanent rose are two useful extra colours.

When you are working with acrylic paints you will need to use quite a lot of white, so always buy white paint in the large tubes. Acrylic colours straight from the tube are very strong. Diluting them with white paint is the equivalent of using water plus the white of the paper in watercolour. Some acrylic colours are transparent and adding white paint will make them opaque – for example, yellow acrylic paint is often not strong enough alone to give good cover. White paint is also brilliant if you need to rescue a painting – just paint out the problem area and start from scratch!

Mixing colours

When I paint, I spread all my colours out on my palette and make decisions about mixing as I go along. You can start by following my suggestions for mixing colours, but in time and with practice you will find that you are mixing the colours that you use regularly almost by instinct. Some of the mixes I use over and over again can be found on page 16–17, including mixes for special effects like shadows.

I always group my paints in a certain way, putting the colours that are usually mixed together next to each other on my palette. Working clockwise from the top of my palette, I start with a generous amount of white, followed by the blues because the sky is usually the first area that I paint. The greens come next, followed by the yellows and earth tones. I always put burnt umber and ultramarine near each other because I mix them together all the time to make dark shades. Cobalt blue and alizarin crimson go next to one another because they are used together for shadow mixes. Find the order of colours that works for you and stick to it, then you will never have to hunt for a colour on your palette or risk making a mistake.

Old Corfu Town

All the colours in my basic palette were used in this painting. The style is mostly watercolour, but the highlights on the panelling of the door were painted in a solid mix of white with a little burnt sienna.

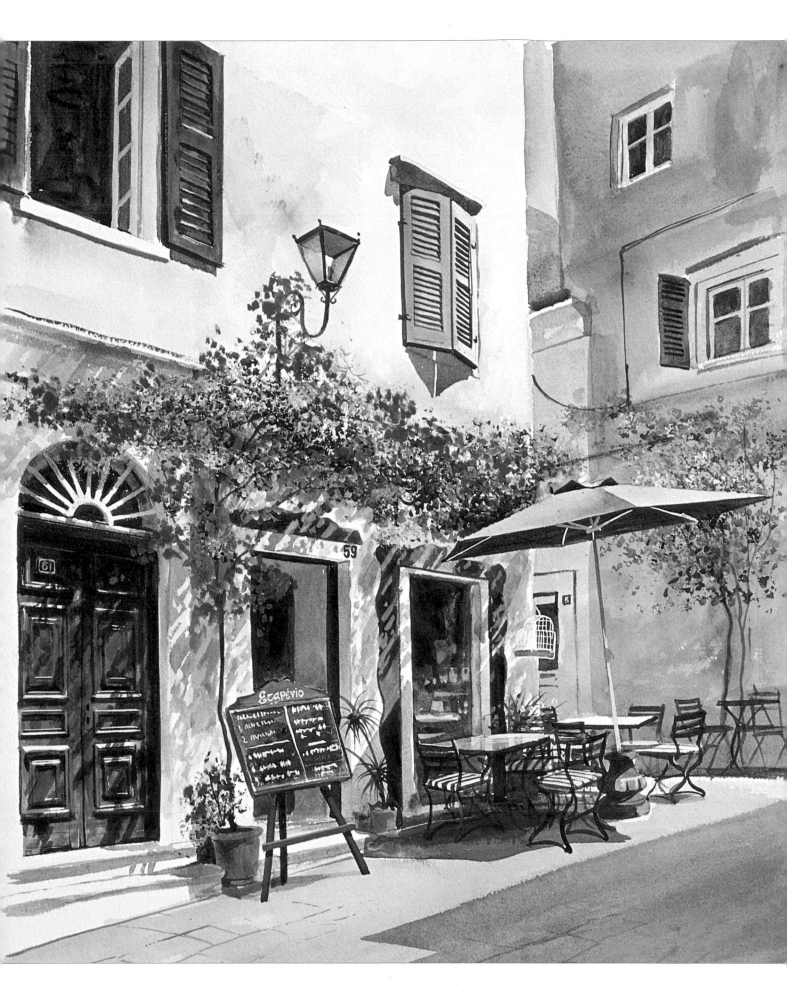

The most useful mixes

There are some mixes that I use again and again – I think I could do them blindfolded! Subtle changes in tone can make a lot of difference. When you experiment with colour mixes, add just a tiny bit at a time. Add too much, and the result may be a horrible muddy shade. Remember that cool colours generally tend towards blue, while warmer earth colours tend towards red. Earth colours can be toned down by adding a little blue.

Mixing greens
Many greens are available ready-mixed. If you do find one that is almost what you want, it is easier to add a bit of yellow or burnt sienna to it than to try to make it from scratch. Remember that the more colours you add to a mix, the muddier it is likely to become. If a green is too bright, it can be toned down by adding a warm, red-toned colour such as burnt sienna or burnt umber. This works well for emerald, which is very unnatural in landscape painting.

Green with white
Mixing white into green makes a range of subtle, opaque shades. Add a small amount of cadmium yellow if it loses its vitality in the process.

Almost black
I never use ready-mixed black paint, as it seems to invade all the other colours and tends to make everything look dull. For a dark shade that gives a far better effect, use a strong mix of ultramarine and burnt umber.

Shadow mixes
For warm shadow, mix cobalt blue and alizarin crimson, then add a little burnt sienna and mix again. For darker shadow, use a strong mix of ultramarine and burnt umber. Another useful shadow mix is ultramarine blue and burnt sienna. For a shadow wash, use cobalt blue because it is not as heavy as ultramarine. For a cooler shadow, add more blue and for a warmer effect add a little alizarin crimson.

Shadow with white
Adding white to shadow mixes produces a range of subtle tones. When you want to make a shadow more opaque, add a little white to the mix. White can also be added if your shadow mix comes out too dark.

Shades of green

Adding burnt umber to Hooker's green produces a nice olive tone.

Adding burnt sienna to Hooker's green tones it down.

Adding white to Hooker's green make it opaque but dull. Add yellow to bring back its vitality.

Almost black

Ultramarine blue and burnt umber make a range of greys that can be almost black.

Shadow mixes

Mix cobalt blue and alizarin crimson...

...then mix the result with burnt sienna for a really subtle effect.

Adding white to cobalt blue and alizarin crimson produces subtle shadows.

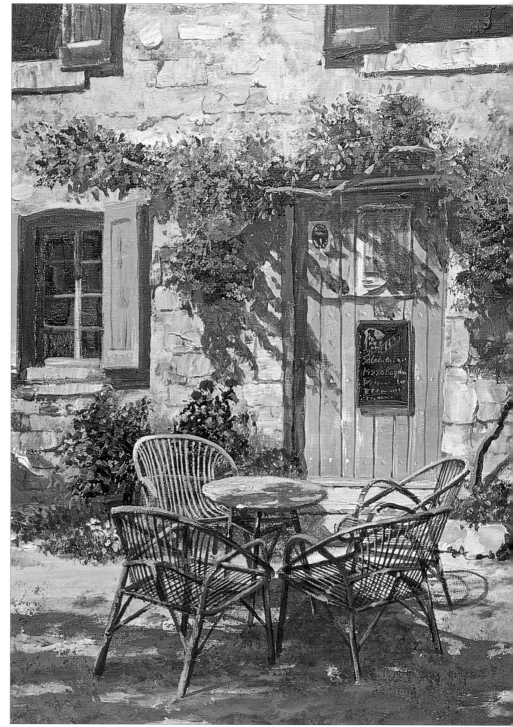

Shady Café

I have used strong shadow mixes for this painting, because the contrast between light, sunlit walls and dark shadow helps to enhance the effect of a painting flooded with light. I used the medium detail brush for the shadows under the vine and round the shutters, and the wizard brush, which gives a softer edge, for the dappled sunlight in the foreground.

17

My brushes

One of the biggest problems for would-be artists is knowing how to use different brushes. Many artists customise or adapt brushes to suit their needs. I have developed my own range of brushes which goes a step further because each is designed to do a particular job. The brushes used in this book are from that range.

Golden leaf

This 2.5cm (1in) brush holds a lot of paint or water, so it is ideal for washes, and can also be used for stippling and flicking. It is made from bristle blended with hair. The hair curls when it is wet and keeps the bristles separate, so it is great for texture. The stiffness of the bristle makes this brush ideal for acrylics.

Foliage brush

This brush is a smaller version of the golden leaf, still stiff. Stippling it over the surface of the paper is a simple way to produce foliage and texture. It is the ideal brush for trees, bushes and hedgerows as well as the textures on buildings, footpaths, walls and roads, and it is the brush I use for bluebells.

Wizard

This natural hair brush looks shaggy and well-used because some of the hair is slightly longer. The body of the brush holds the paint, which is released through the longer hair to form small points and produce the effect of fine lines. It is good for grasses, hair and fur, as well as for blending water and reflections.

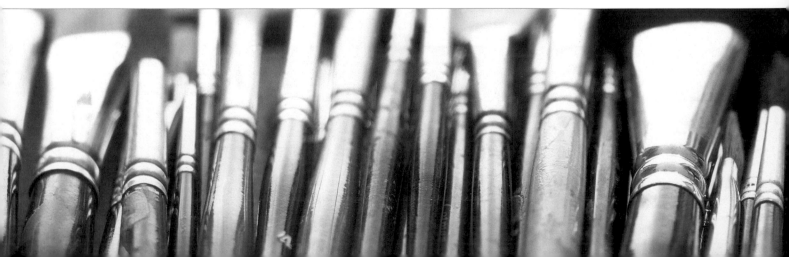

Fan stippler

As its name suggests, this brush is usually used for stippling on paint. A blend of hair and bristle helps to produce interesting textural effects. It is good for mimicking nature, especially for realistic leaf effects. The shape makes it ideal for trees.

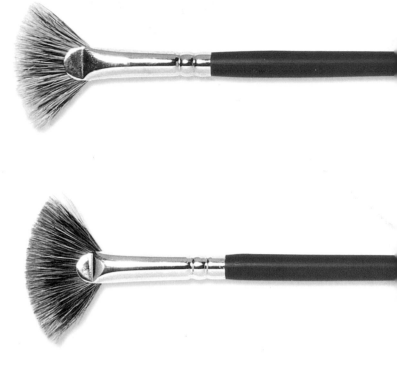

Fan gogh

This brush is made from a blend of natural hair and holds lots of paint. It is thicker than many other fan brushes so the hairs do not separate. It can be used for a wide range of trees including cypresses, firs, willows and palms; for grasses and reeds; for textures like fur, and even for reflections on water.

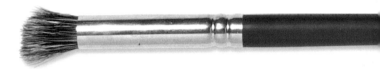

Deerfoot stippler

The stippling brush is in the same family as the golden leaf, the fan stippler and the foliage brush. It was traditionally used in decorative and folk art. This version, made from natural hair, is ideal for painting texture and trees.

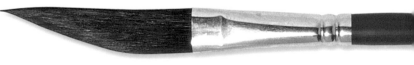

Sword

This brush, originally used for decorating pottery, has become very popular with painters. It is great for painting grasses and rushes by water, and is also useful for painting sweeping leaves for certain flowers.

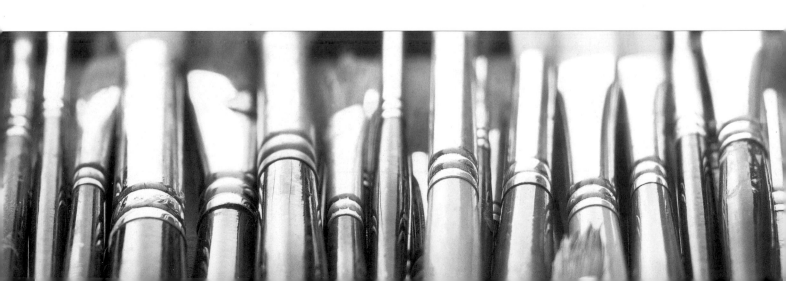

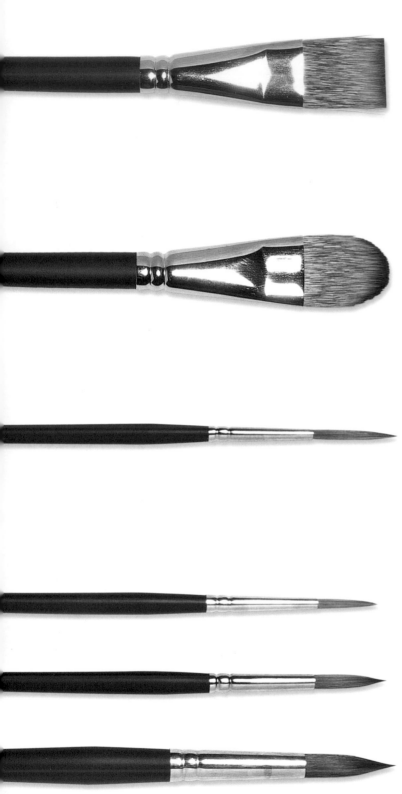

Flat brush

This 19mm (¾in) flat brush holds a lot of paint, so it can be used for washes as well as for some interesting effects. It can be used to block in colour, used fairly dry for streaking, and to produce a straight edge, so it works well for buildings and man-made structures.

Oval brush

This synthetic brush also holds a lot of paint and is useful for washes. Its shape is a help when creating effects such as clouds, the rounded tops of trees and smooth rocks.

Half-rigger

This synthetic brush is designed to keep its point and shape. It is shorter than an ordinary rigger, so it is easier to control. It is useful for painting grasses and flowers as well as for rigging. It holds enough paint to complete a long, unbroken line.

Small, medium and large detail

These synthetic brushes are also known as round. I find that three sizes – small, medium and large – give me all the scope I need. The small detail brush is best for refining and sharpening up sections of your painting and, of course, adding your signature. The medium detail is the one I use most often: it will go to quite a fine point, and is suitable for adding all but the finest detail. The large detail brush is extremely versatile. It holds a lot of paint yet still goes to quite a fine point, and can be used for anything from washing in skies to adding a determined statement to a painting.

Sunlit Barn
I used all the brushes shown in this book to paint this rural scene.

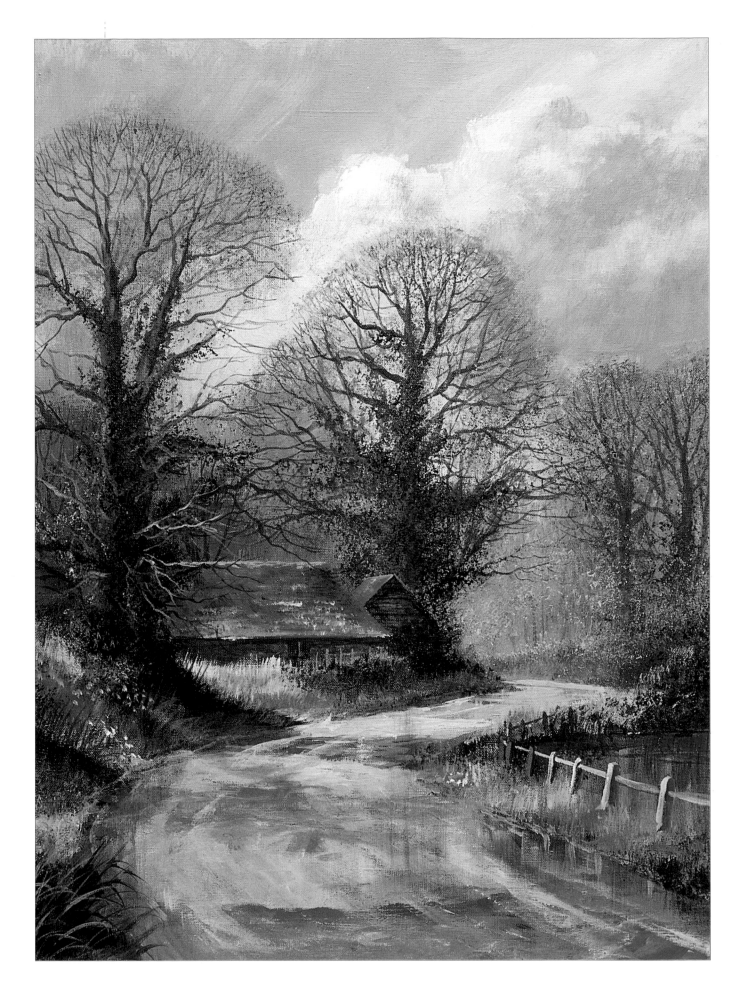

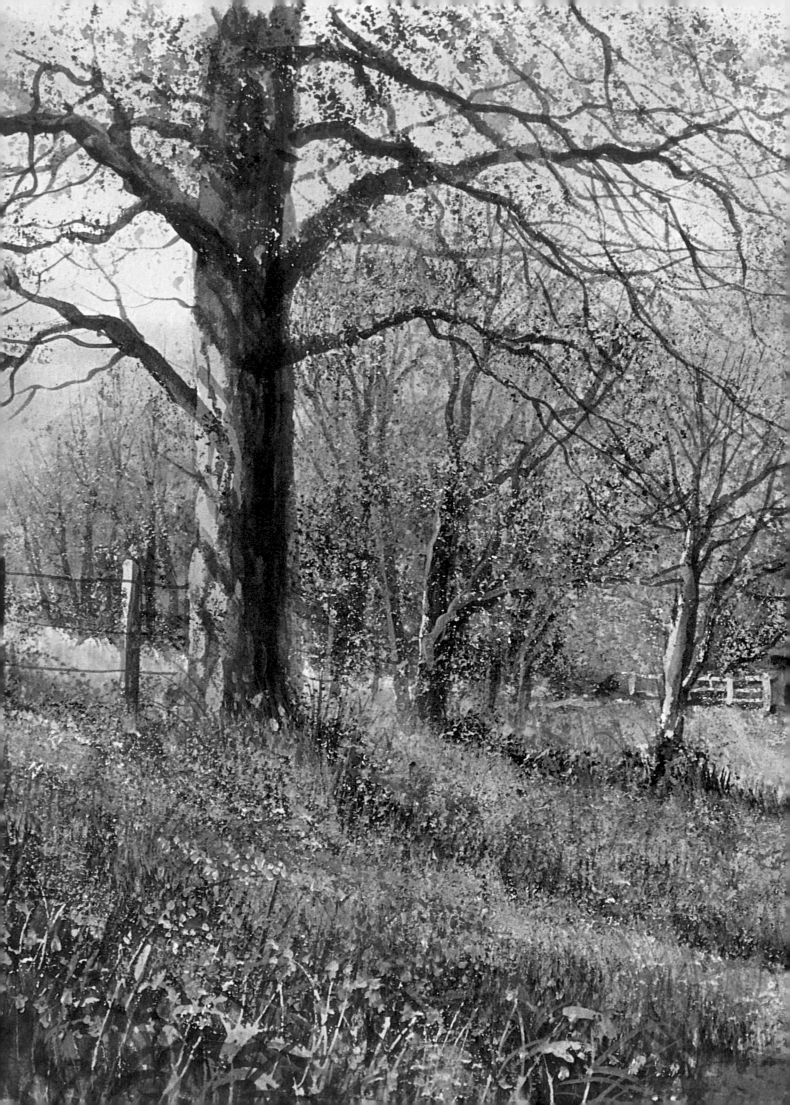

USING THE
BRUSHES

Golden leaf

This brush is ideal for washes, either on a dry background, or wet-in-wet over water or colour. Acrylic dries fast, but there is still plenty of time to blend washes. It is also good for texture and flicking up foliage. Before using for the first time, dip it in hot water so the hair curls and the bristles separate. Repeat occasionally to keep it in good condition.

Simple tree

The brush can be used almost dry to stipple on texture, giving an effect similar to that achieved with a sponge.

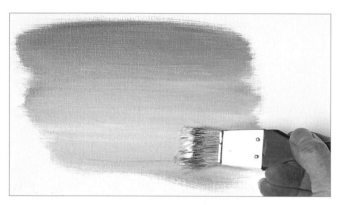

1. Using cobalt blue, put in a wash for the sky, blending in a touch of white towards the bottom.

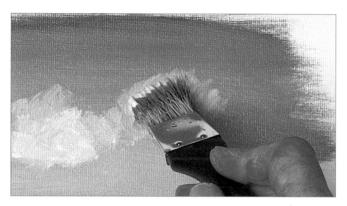

2. Using cobalt blue, darken the top slightly then, working wet-in-wet, dab on white for the clouds.

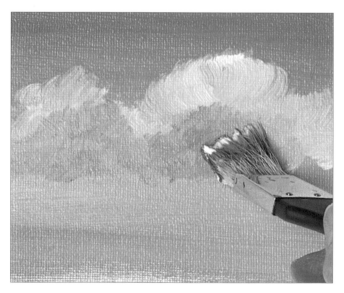

3. Put in darker shadow under the clouds using a mix of burnt umber and ultramarine.

4. Put in a trunk using a mix of Hooker's green and burnt umber and the large detail brush. Leave to dry, then stipple over the trunk using the golden leaf and Hooker's green to give a hint of foliage.

5. Using the same brush, complete the foliage by stippling over it with pale olive green.

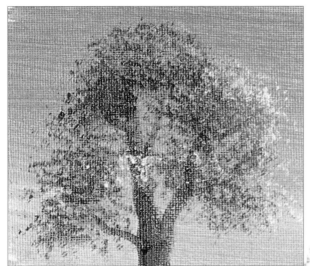

The completed foliage

Tip
The golden leaf brush holds a lot of paint. Take care if you use it for stippling – if you use the brush too wet, the texture may fill in. Take out as much of the water as possible, either by squeezing with your fingers or dabbing it on absorbent paper.

6. Use a flicking movement round the base of the tree to create grass.

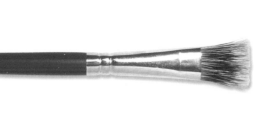

Foliage brush

Naturalistic foliage is easy to produce by stippling with this brush. Make sure it is not too wet, or the texture will fill in. For a more realistic effect when painting trees, do not mix the colours too thoroughly.

Tree with ivy

Put in the sky first, using the golden leaf brush and cobalt blue blended with a little raw sienna towards the horizon.

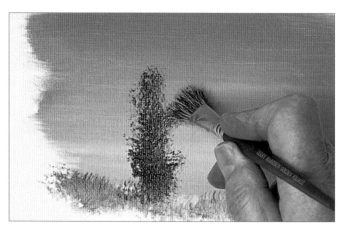

1. Using the foliage brush and a mix of pale olive green and Hooker's green, flick up a little grass beneath the tree. Stipple on the ivy using Hooker's green.

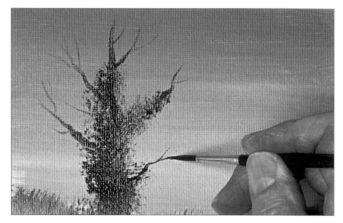

2. Using the small detail brush and Hooker's green with a little burnt umber, add some branches, working from the base up and painting in the direction that the tree grows.

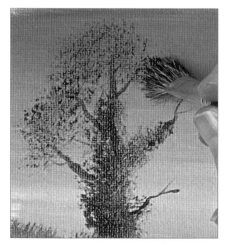

3. Using the foliage brush held at right angles to the surface and Hooker's green, stipple on the foliage.

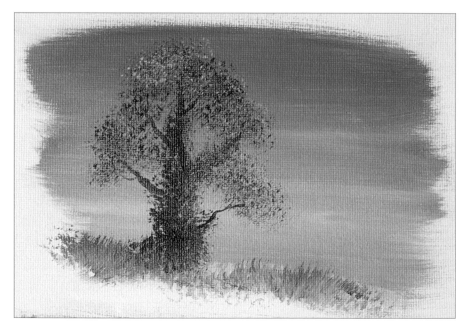

4. Using pale olive green, stipple in a few highlights on top of the dark background.

Flint walls

If you look at flint walls, there are actually lots of different colours. The easiest way to reproduce these is to use the foliage brush to create the texture and tones of the flint, then pick out the detail with a small detail brush.

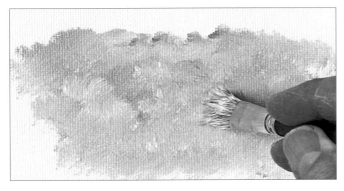

1. Using a mix of white and cobalt blue, put on the paint very thickly by dabbing it on the canvas. Leave it to dry.

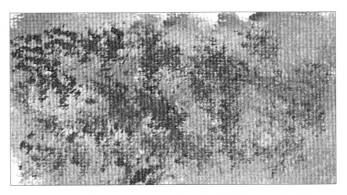

2. Using different mixes of cobalt blue and white with a touch of burnt umber, stipple all over to create texture and tone.

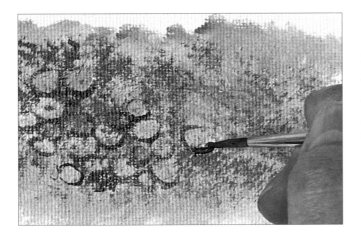

3. Using a mix of cobalt blue and burnt umber and the small detail brush, paint in the shading underneath each stone. Look for the shapes in your work and put a line round each.

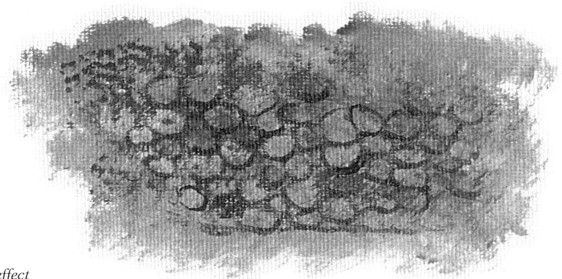

The finished effect

Footpath

A feature like this is an ideal way to lead the eye into a painting. The foliage brush can be used for grass, stones, shading and stippling.

1. Lay down a wash of raw sienna and white, making it darker towards the foreground. Working wet-in-wet, stipple in a mix of raw sienna and burnt umber for the texture on the path.

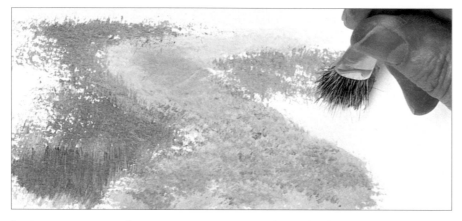

2. Start to put in the grass using mixes of Hooker's green and pale olive green, varying the shades. Add texture by stippling with the brush held vertically.

3. Towards the foreground, stroke downwards with the brush to add the grass.

4. Using the small detail brush and white with a touch of raw sienna, paint in some stones.

5. With a mix of ultramarine and burnt umber, add the shadows under the stones.

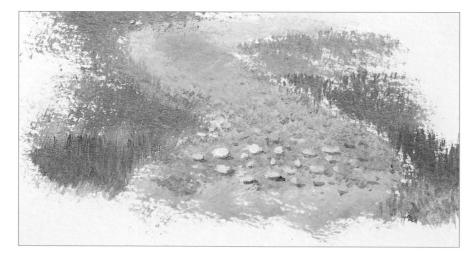

The finished path

Hilltop View

This painting on canvas shows the many textures it is possible to achieve using the foliage brush. It was used for the sky, trees, hedgerows and grass.

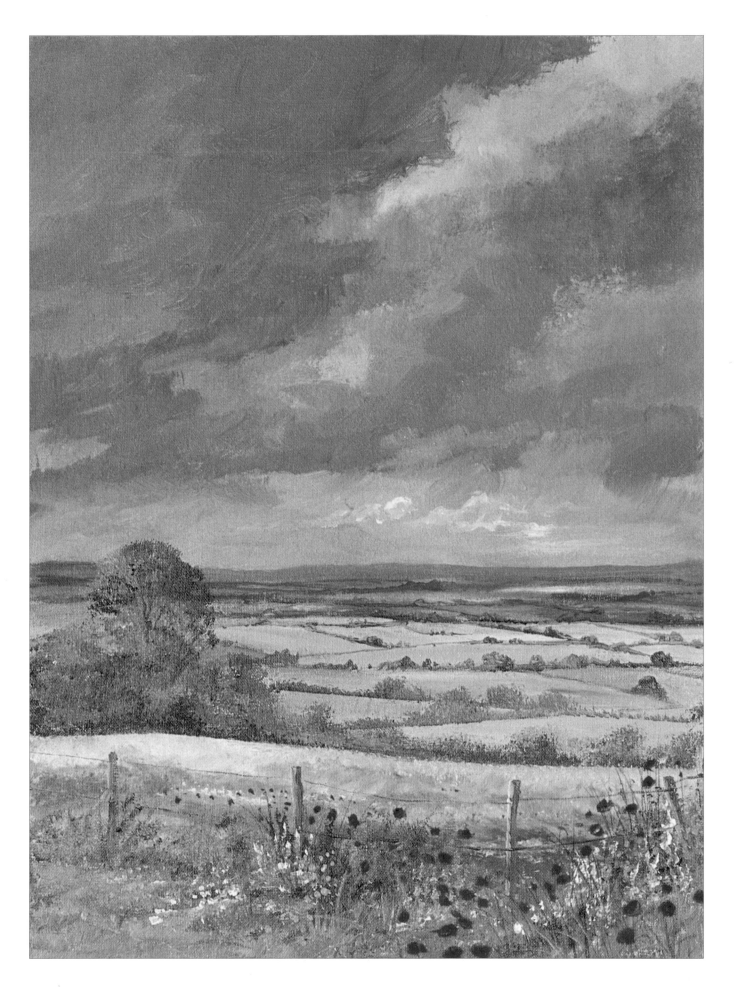

Wizard

This brush is good for many different textures, particularly shadows with undefined edges and small, delicate grasses. For larger clumps of grass use the fan gogh.

Making marks

Results achieved with the wizard will vary according to the amount of water you use and the degree of pressure applied, so experiment. For streaked effects keep the pressure light but even, and for a wash apply more pressure.

Use horizontal streaks to add texture like this...

...and upward streaks or 'flicks' to produce simple grass.

For a wood grain effect, wiggle the brush as you drag it down.

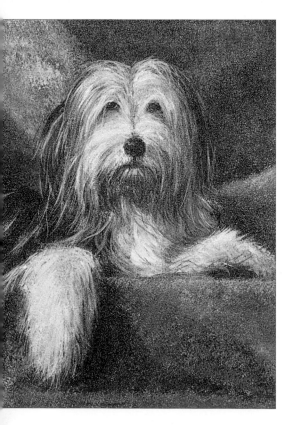

Using the brush dry produces an interesting texture.

Shaggy dog
The wizard is
also ideal for fur!

Curving streaks as you paint produces a waterfall effect.

Waterfall

The effect of water is fast and easy to achieve using the wizard brush. This example begins with rocks painted using the credit card technique – see page 65.

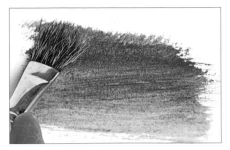

1. Using a mix of cobalt blue and burnt umber, apply a thick background wash for the rocks.

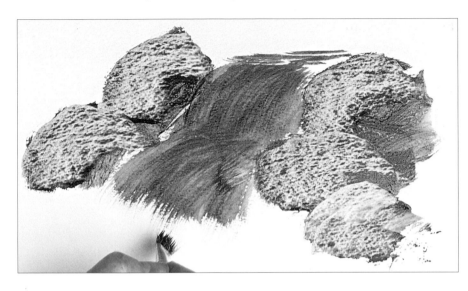

2. Following the credit card technique, scrape off the rocks. Using the wizard and a mix of ultramarine with just a touch of Hooker's green, stroke on the water following the contours of the rocks.

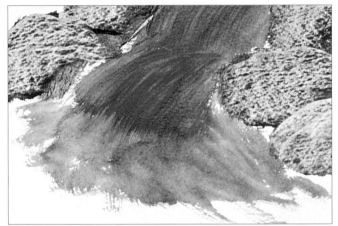

3. Using the same paint mix and a dabbing movement, put in the water in the foreground.

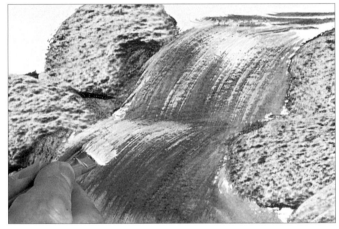

4. Load the brush fully with white and stroke over the surface, using the end of the brush and following the direction of the water.

5. Still using white, almost neat from the tube, dab and stroke on the effect of foam on the water in the foreground.

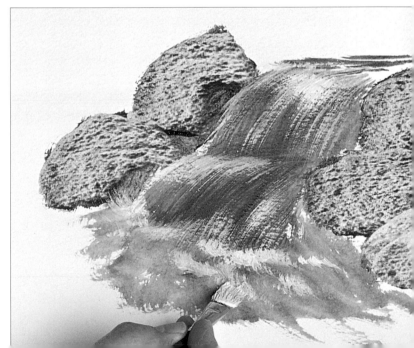

Reflections

The wizard is ideal for adding reflections of trees in water because it produces a streaked effect. Here, a basic sky was completed using the golden leaf, and the trees were painted using the foliage brush. The small detail brush was used for the trunks, branches and fences. In the foreground, the wizard was used to add the grasses and highlights.

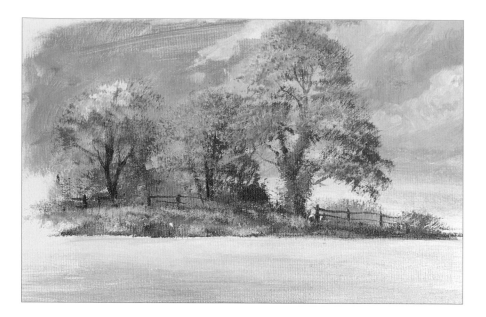

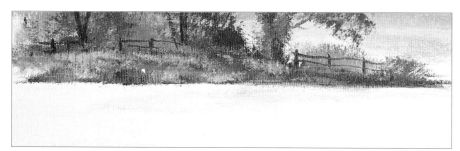

1. Put in a foreground wash of cobalt blue, blending it progressively with white towards the bank.

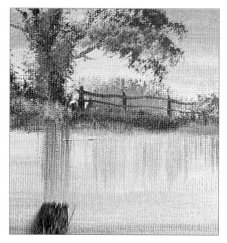

2. While the wash is still wet, begin to build up the reflections, using the same colours as for the elements of the painting above and dragging them down into the water.

3. Put in the bank with a mix of burnt umber and Hooker's green, then, using the same colour mix, drag down the reflections in the water.

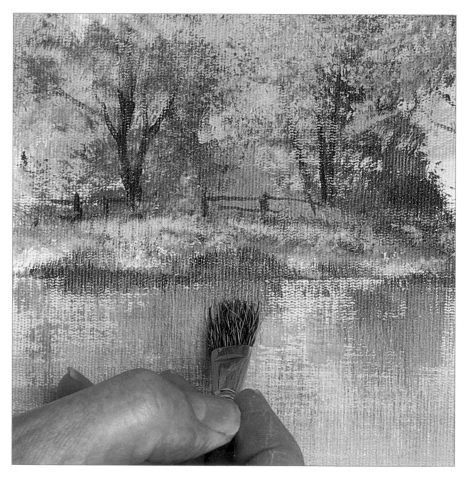

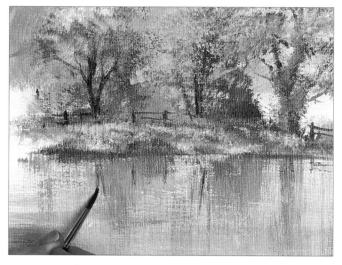

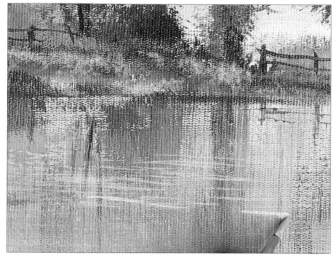

4. Using the small detail brush and a mix of burnt umber and Hooker's green, put in the reflections of the fence posts and trees.

5. Still with the small detail brush, paint in the ripples on the surface of the water using white with just a touch of cobalt blue.

The finished picture

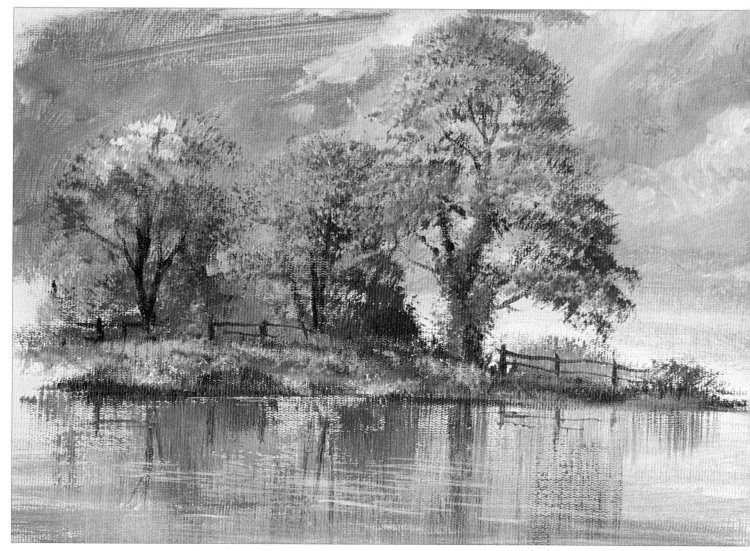

Fan stippler

This brush produces a really natural leaf effect. The technique varies according to how much foliage you want – note that silver birches do not have a lot of foliage. For sparse foliage, stipple lightly and for a denser effect, push harder. Take care not to wet the brush too much or the paint will just flood the painting. Texture can also be built by using thicker paint.

Silver birch

Paint in the trunk first using the medium detail brush and white toned down with cobalt blue and a touch of burnt sienna.

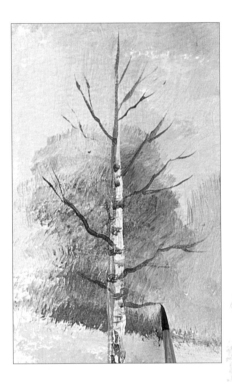

1. Add branches using the small detail brush and a mix of ultramarine and burnt umber.

2. Stipple on fairly sparse foliage using mixes of pale olive green and Hooker's green.

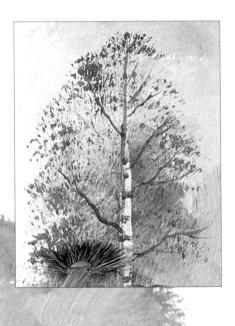

Tip
The trunk of the silver birch can also be painted using a palette knife – see page 69.

3. Add foreground detail by flicking up with the brush, using various mixes of green and white.

Summer tree

When a tree is in full leaf, I build up the foliage first, then put in the trunk and branches later with a detail brush.

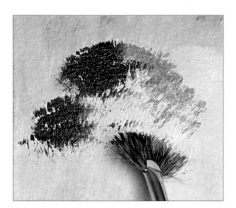

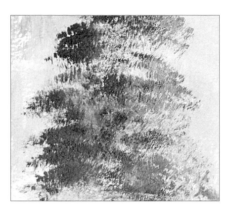

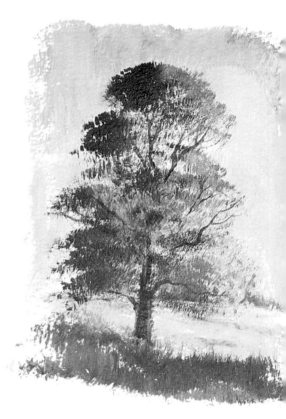

1. Load the brush with pale olive green on one side and Hooker's green on the other (double-loading). Begin to put in the foliage at the top, turning the brush to vary the effect.

2. Add highlights to the sunlit foliage using a mix of pale olive green and white.

3. Using a small detail brush and a mix of Hooker's green and burnt umber, put in the trunk and branches.

Autumn tree

The shape of the brush is the shape of the tree. Golden ochre, which is not in my basic palette, is ideal for autumn foliage. The foreground grass tones include autumnal browns.

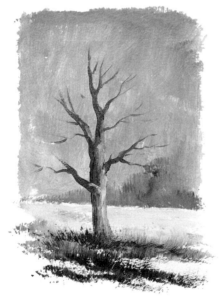

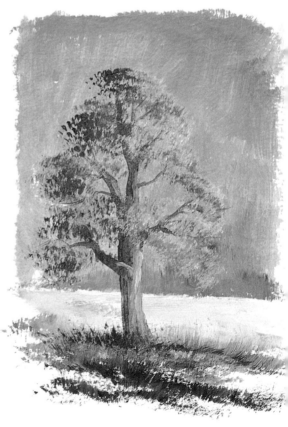

1. Using the medium detail and a mix of burnt umber and pale olive green, paint the trunk. Add shadows with a mix of Hooker's green and burnt umber. Flick up grasses using burnt umber.

2. Stipple in a mix of burnt sienna and cobalt blue, then stipple a lighter mix of golden ochre and burnt sienna on top.

3. Using white with a touch of cadmium yellow, put in the highlights. Add fallen leaves under the tree with the colours used for the foliage.

Winter tree

For this tree in winter, the ivy-covered trunk was put in first using the double-loading technique (see step 1, page 35). Branches were added with the half-rigger, making them progressively darker toward the foreground to increase the sense of perspective. There was no foliage but the brush was ideal for adding a snow effect to the twig canopy.

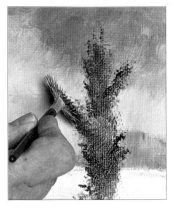

1. Holding the brush at right angles to the surface, dab on Hooker's green. The effect will be darker where there is more paint on the brush.

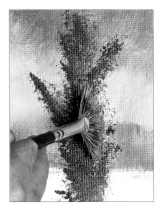

2. Dab on highlights down the sunlit side of the tree using pale olive green.

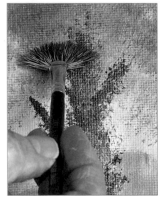

3. Using the brush at right angles to the surface and a mix of ultramarine and burnt sienna with a touch of white, dab in the canopy of twigs.

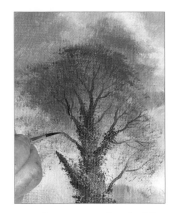

4. Change to the half-rigger and a mix of cobalt blue and burnt umber to paint in the network of branches.

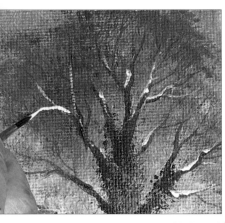

5. Using the small detail brush, paint in snow lying on the edge of some of the branches.

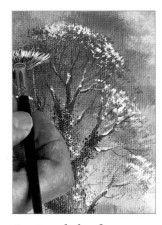

6. Load the fan stippler thickly with white and dab in the snow on the furthest reaches of the twig canopy. Lay the paint on almost straight from the tube to give the texture of snow.

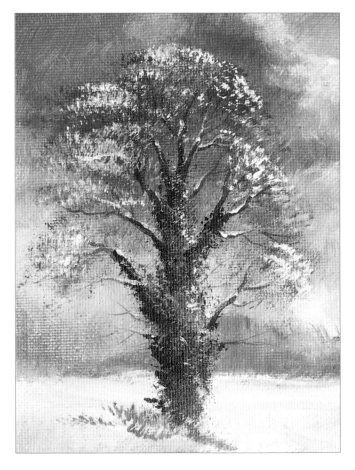

Copse

The fan stippler is ideal for painting in copses using the double-loading technique. This example below uses two shades of green and a little yellow ochre to give a sunlit effect. For larger copses use the fan gogh.

1. Double-load the brush with Hooker's green and pale olive green and paint in the first tree.

2. Add a second tree in the same way, but make sure that light paint overlaps the dark.

3. Double-load the brush again and complete the third tree, this time putting a tiny amount of yellow ochre on the centre of the brush to add highlights.

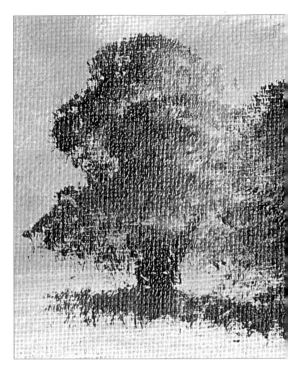

The finished picture
The trunks and branches were painted using the small detail brush

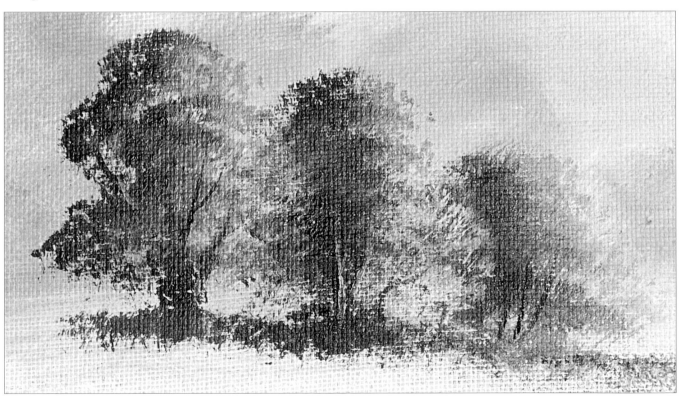

Fan gogh

I think of this as the 'tree brush' because it is perfect for building up foliage effects. Though it is made of soft hair, it has plenty of spring so it can be used with acrylic paint.

1-2-3 Cypress

This type of tree couldn't be easier to paint using the fan gogh brush. Load the brush with light paint first and complete one half of the tree, then load again with a darker shade and put in the other side. Paint from the outside of the tree to the centre: the shape of the bristles makes this quite simple to do. In fact, if you practise this technique a few times, you will see that it really is as easy as 1-2-3.

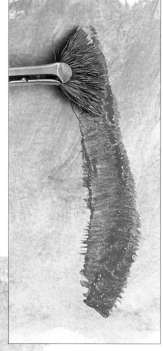

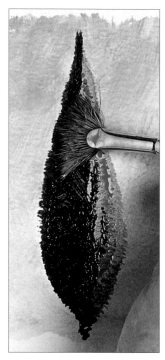

1. Load the brush with pale olive green and hold it vertically and at right angles to the surface to put in the light side of the tree.

2. Reload the brush with Hooker's green and put in the darker side of the tree in the same way.

3. Add the grass at the bottom of the tree with a few flicks of both colours.

Summer tree

The technique for this tree is a little different from the technique used for a similar tree in watercolour. I put the trunk in first because, with acrylic paint, there is no risk of moving the paint when you add foliage over the top. Opaque highlights add an extra dimension.

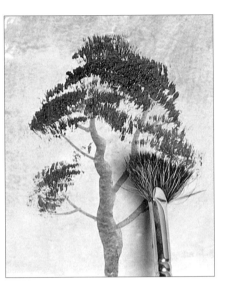

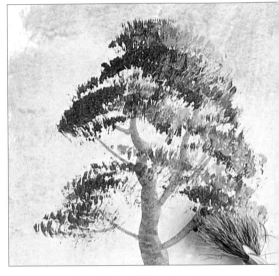

1. Using the medium detail brush and a mix of Hooker's green and burnt umber, put in the tree trunk.

2. Using Hooker's green and dabbing with the fan gogh, put in the foliage. Lay the brush flat, then tilt it to use the edges.

3. Using the edge of the brush and a mix of pale olive green with just a touch of white, touch in the sunlit side of the tree.

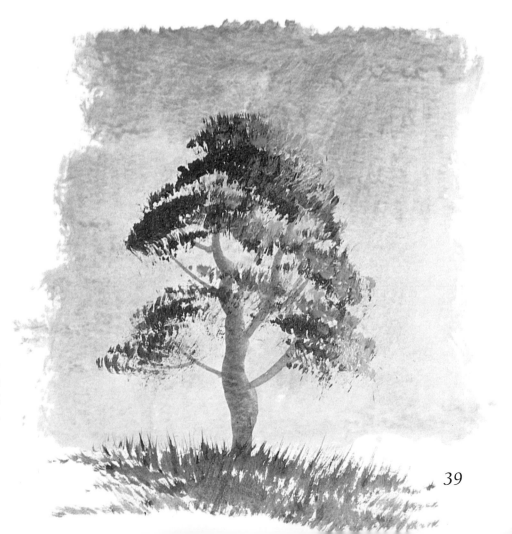

4. Add grass by flicking up with the brush at the bottom of the tree using mixes of Hooker's green and pale olive green.

Palm tree

The technique for painting a palm tree is amazingly easy. The foliage is painted directly on to the surface and there is no need to put in the branches first. Paint the trunk using burnt umber and a dry medium detail brush.

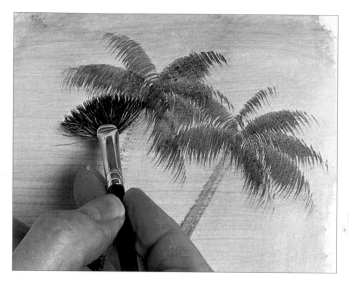

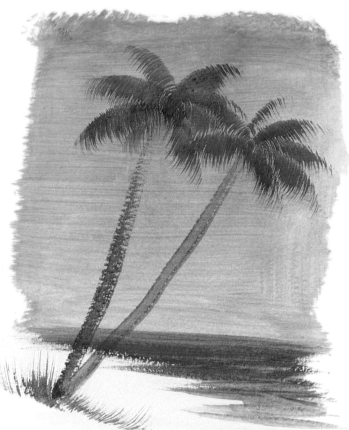

1. Load the brush with Hooker's green and put in each section with one stroke of the brush. Make sure that you start each stroke with the far edge of the brush in the same place, and let the paint flow from the very end of the brush.

2. Add some grass beneath the tree by flicking upwards using the same brush and a mix of Hooker's green and pale olive green.

Variation

Some people prefer to paint in the branches of a tree first, so here is a slightly different way to form the top of the palm tree.

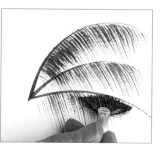

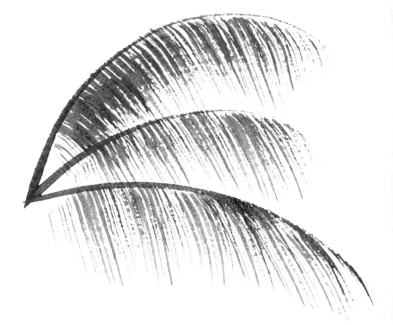

1. Paint in the branch using Hooker's green and sweeping strokes of the half-rigger.

2. Load the fan gogh with Hooker's green. Touch just the middle of the brush on the branch, then drag downwards and away from the stem.

Fir tree

A fir tree may look complicated, but this simple technique means it can be painted quickly using just one brush. The brush hairs bend against the surface of the paper, and the thickness at the centre of the stroke gives the thickness of the branch.

1. Holding the brush vertically and using Hooker's green, dab in the trunk.

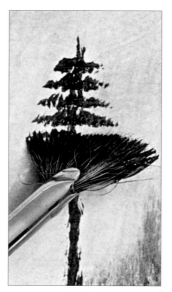

2. Using the tip of the brush and very tiny brush strokes, put in the top branches.

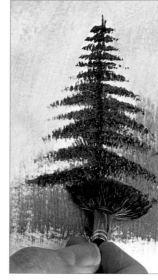

3. Add the larger branches, pushing the brush firmly against the surface so the hair at the end bends.

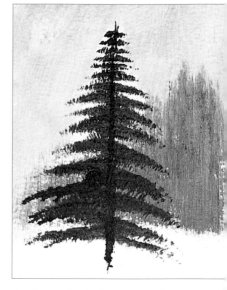

4. Complete the rest of the tree.

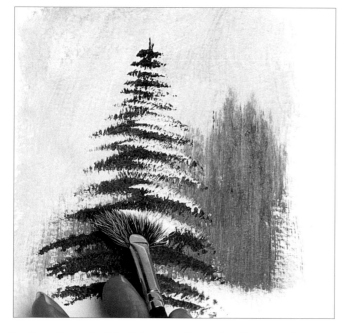

5. Load one half of the brush with white and touch it on to the branches on one side of the tree.

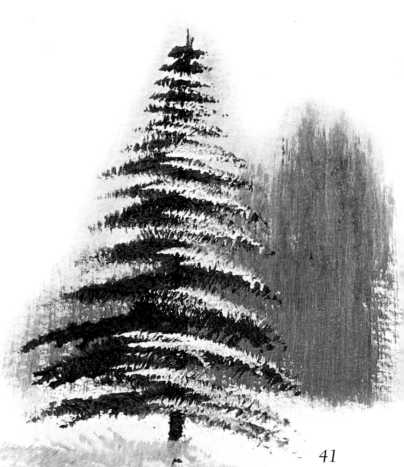

Willow

I use two different ways to create realistic willow trees. The first method, which is ideal for young trees, is to put in the shape of the boughs, then stroke the foliage on afterwards. Use the tips of the fan, so the paint flows through and out of the end of the brush, forming streaks.

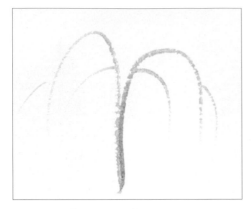

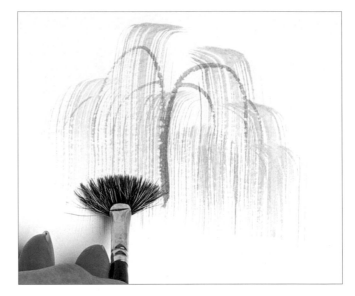

1. Using burnt umber and a fairly dry half-rigger, put in the shape of the boughs.

2. Using pale olive green and a fairly dry fan gogh, stroke on the foliage as shown.

Variation

My alternative way to reproduce willow trees dispenses with branches entirely and is ideal for mature specimens with lots of lush foliage.

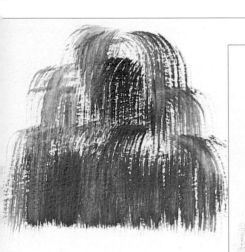

1. Using a fairly dry brush and Hooker's green, stroke on the shape of the tree.

2. Add some pale olive green to the tips of the bristles and stroke on to produce a streaked, cascade effect.

3. Using a mix of pale olive green and white, hold the brush at right angles to the surface and stroke on to the tree, following the fall of the foliage, to create subtle shades and tones.

Grass

Basic grass, which is useful in the foreground of a picture, can be produced simply by flicking the fan gogh brush upwards. Use a fairly dry brush to produce a convincing effect.

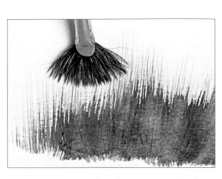

1. Using Hooker's green, flick upwards with the brush.

2. Touch a little pale olive green on the brush to add lighter tones.

Adding interest

Useful and interesting effects can be achieved by adding simple detail to the basic grass. Start by completing the basic grass by flicking up with the fan gogh, then turn the brush on its side...

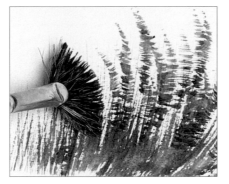

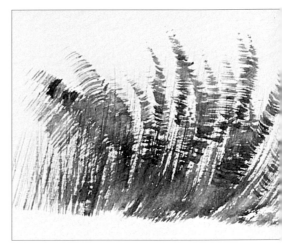

...and touch it to the surface, pulling slightly, to produce the effect of ferns.

Adding flowers

Another simple technique adds flowers and ferns to the basic grass with just one stroke of the brush. First, load the brush with green, then touch one end with red.

Turn the brush sideways and practise the technique on a spare piece of paper before adding the flowers to the tips of the grasses – see the finished example below.

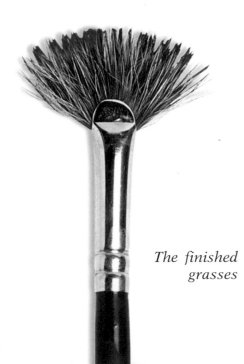

The finished grasses

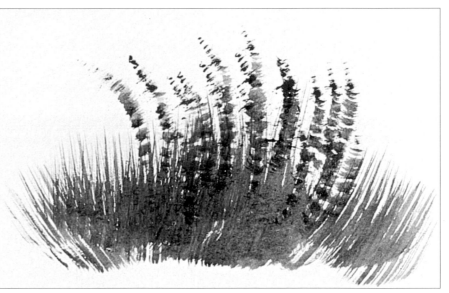

Meadow grass

This is produced by flicking up with the brush and using a range of colours.

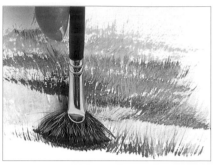

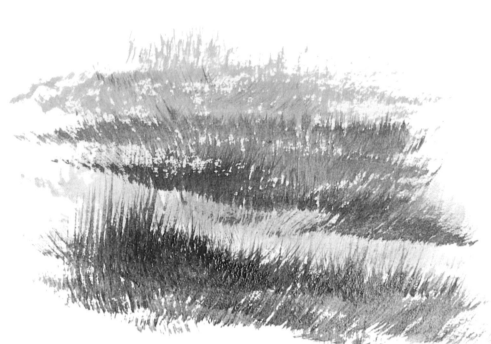

Reflections

The fan gogh is also fantastic for adding reflections. Start with the copse shown on page 37, which was completed using the fan stippler. Using the same paint colours as for the trees, drag the reflections down into the water area.

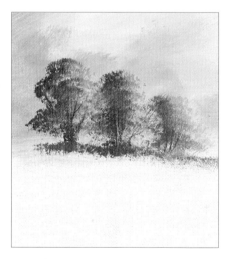

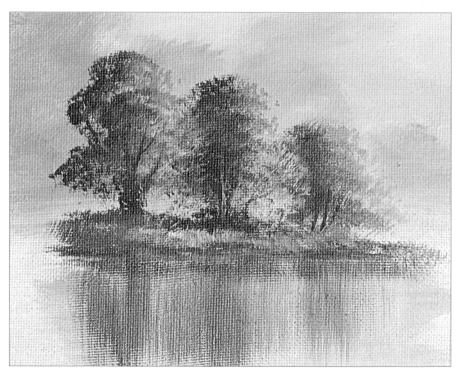

1. Wet the expanse of white surface in the foreground...

2. ...and add the colours of the trees wet-in-wet to build up the reflections.

Opposite
Monet's Garden
This painting is not the first to be inspired by the famous garden at Giverny!

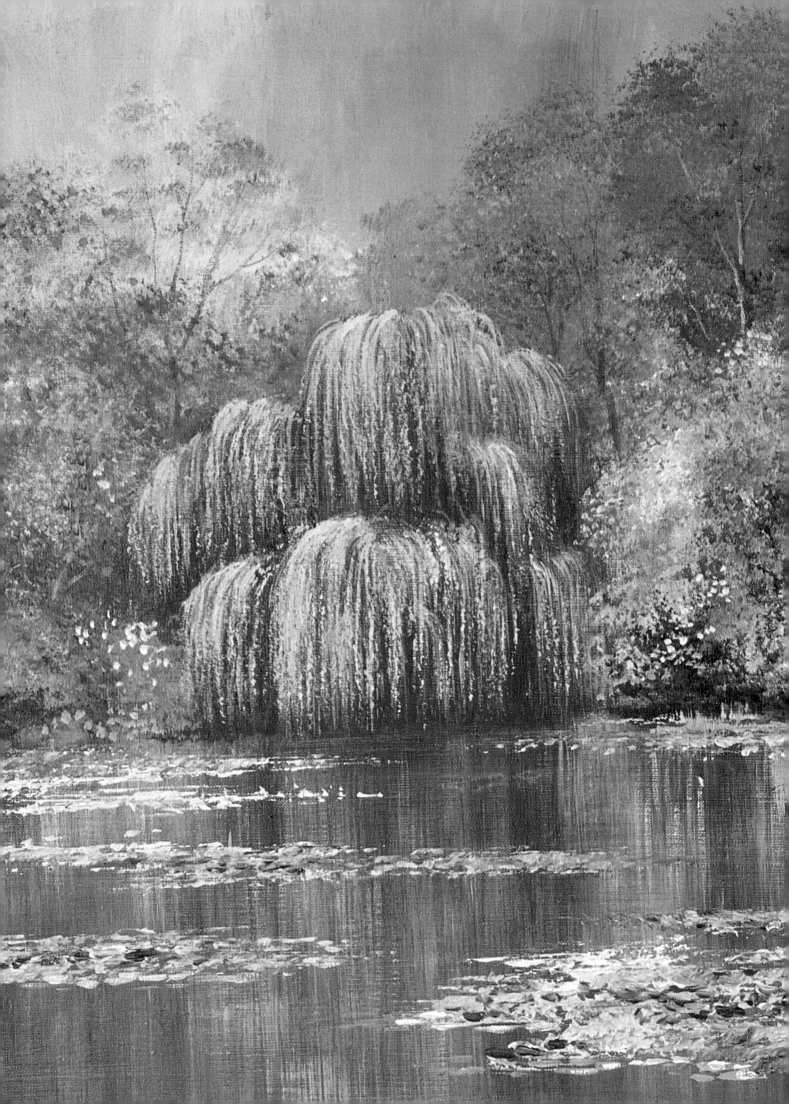

Deerfoot stippler

This brush is particularly useful with acrylic paint, and works best when it is used to stipple on texture. Make sure it is not too wet: if you really want to build texture it can be used almost dry, and the paint can be used virtually neat from the tube.

The deerfoot stippler is ideal for creating foliage effects very simply, as in these examples.

Walls

The deerfoot stippler is also ideal for creating a range of textures.

A simple texture suitable for a stucco wall was stippled on using a mix of earth tones.

A background wash of raw sienna was stippled with white mixed with cobalt blue and raw sienna.

Brick wall

The deerfoot stippler is used for the texture, then the shapes of the bricks or stones are picked out using a small detail brush.

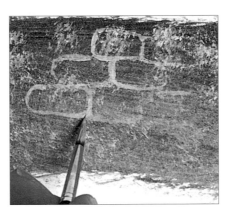

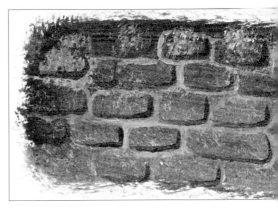

1. Stipple in the wall textures in a mix of ultramarine, burnt umber and white, adding lighter patches for individual bricks.

2. Using the small detail brush and a mix of white with a little cobalt blue for the mortar, pick out the shapes of the bricks.

3. Using a mix of ultramarine and burnt umber, add some shadow under and down one side of each individual brick.

Stone wall

A light, stippled background is ideal for stone walls and a small detail brush is used to pick out the shapes.

1. Start by stippling in a background using burnt umber and ultramarine.

2. Using a small detail brush and a mix of ultramarine and burnt umber, paint the shapes of the stones.

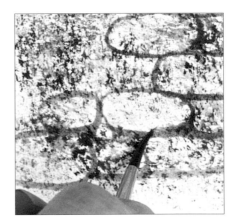

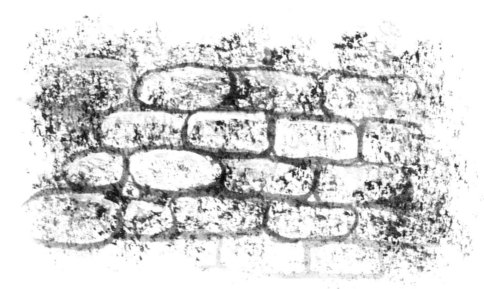

The finished wall
White highlights have been added to the tops of some of the stones.

Sword

Painting grasses and rushes is easy once you learn how to use this brush. The best way to use it is to treat it like a blade, directing it away from your body as you work.

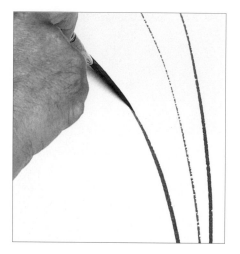

1. Using Hooker's green and bold, upward strokes of the brush, put in the grass stalks.

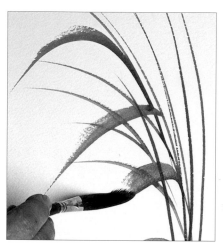

2. Turn the brush and drag it sideways and down in sweeping strokes for the leaves.

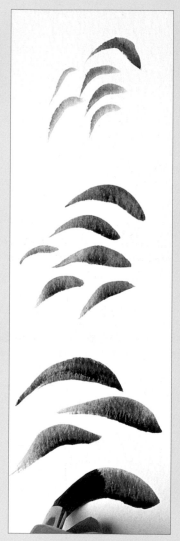

Tip
The brush will produce leaves of different sizes if you change the amount of pressure you apply. Practise on a spare piece of paper.

The finished grasses

Bulrushes

A simple way to produce effective bulrushes is to complete the basic grasses, then add the characteristic heads in burnt umber. Just one downward stroke of the brush is all you will need!

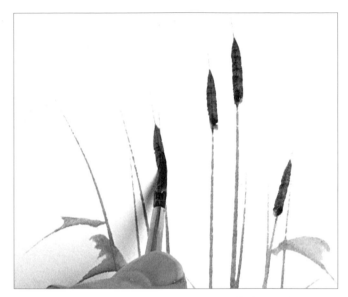

2. Using burnt umber and the small detail brush, add the brown heads with one downward stroke.

1. Complete a basic clump of reeds using the techniques shown opposite.

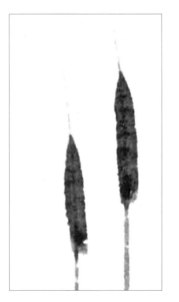

Left: a detail of the bulrush heads

Right: the finished bulrushes

Flat brush

This 19mm (¾in) flat brush can be used for so many things, including blocking in, skies, producing streaked effects, creating reflections and putting ripples on water. It can even be used to create convincing brick effects – see what you can do with it!

Washing in skies

Using the edge to put in ripples

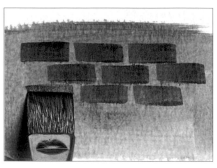

Creating convincing brick effects

Flat brush shed

This shed was painted entirely with the flat brush, from the preliminary washes for the walls and door to the shadows under the eaves and the 'corrugated' roof. The planks and window frames were put in using the edge of the brush.

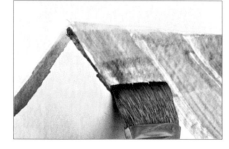

Dragging downwards for the corrugated roof

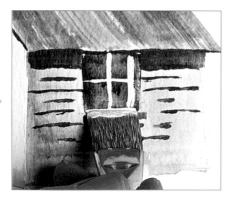

Painting in the window frames using white

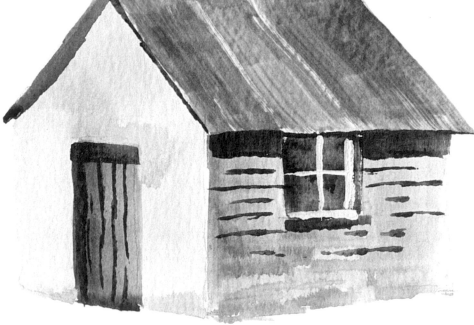

The finished shed

Oval brush

The oval brush is extremely versatile and can be used for a whole range of effects including blocking in and large washes. The round shape means it can be used to produce skies with no straight edges, and it is particularly good for rocks and other curved surfaces.

Use the brush to block in...

...and to paint in cloud shapes...

...and to add highlights to clouds.

The curved shape of the brush makes it ideal for painting rocks.

Half-rigger

The main purpose of the half-rigger brush is clear from its name. It is ideal for painting continuous lines so it is the obvious choice for the rigging of boats. Make sure you load the brush fully so that it holds as much paint as possible and you do not have to take it off the surface to reload. The half-rigger can also be used to paint in fine grasses or to add details such as tiny flower heads.

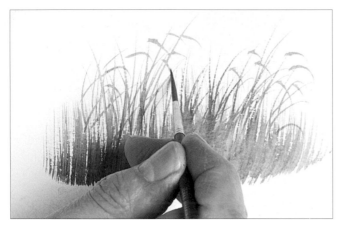

Use the half-rigger brush to paint in fine grasses...

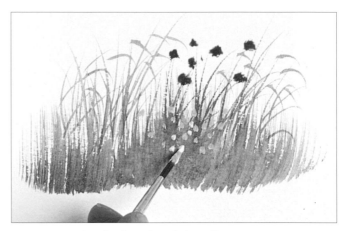

...or to put in the heads of tiny flowers.

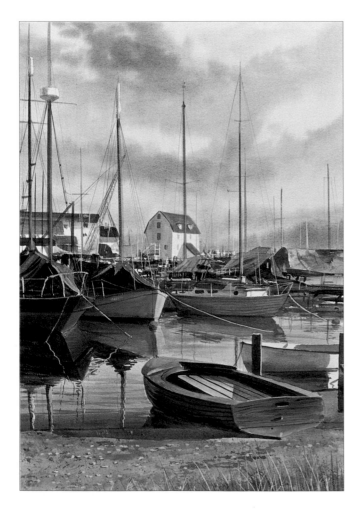

The Tide Mill

This is a different view of a familiar scene, the tide mill at Woodbridge in Suffolk. Though tiny and seen from an unusual angle, the mill is still the focal point of the painting. I have used lots of rigging to add interest, using a ruler held just off the surface of the painting to guide the strokes made with the half-rigger. The small rowing boat in the foreground helps to lead the eye into the scene.

Opposite
Old Thames Barges

This painting on watercolour paper has a lot of detail and also makes extensive use of rigging. Pay special attention to the rigging because it is an important part of the construction of a boat. You will need reference material because you can't just make it up. Masking fluid was used for the pebbles on the beach in the foreground.

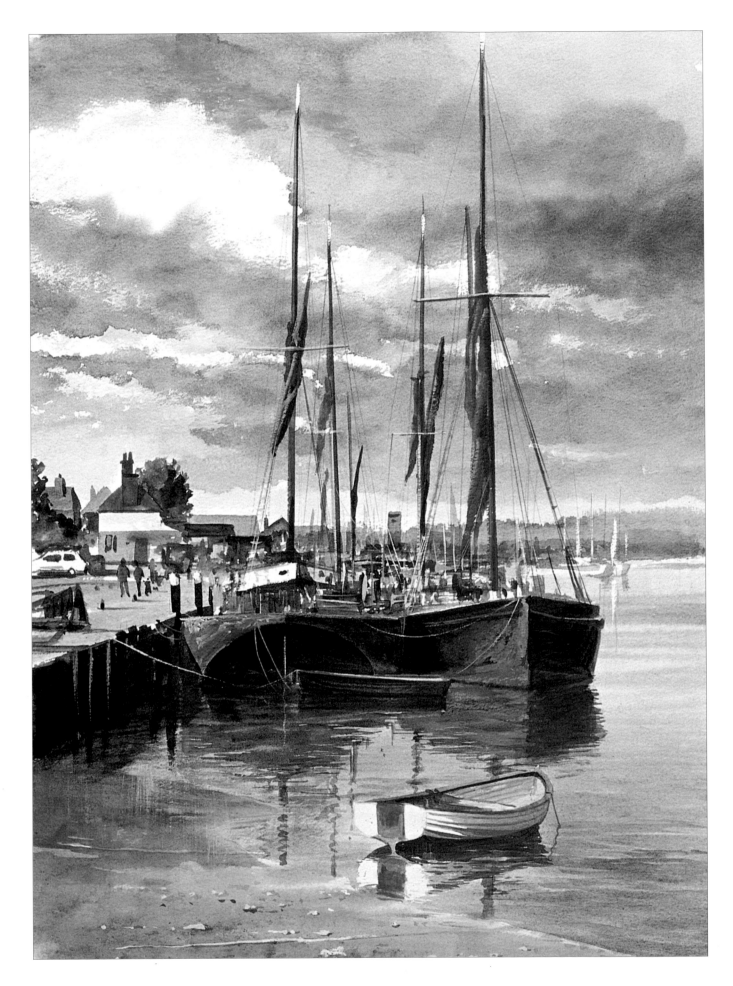

53

Detail brushes

Round or detail brushes are available in lots of sizes. Your choice will largely depend on the size of your painting. Whatever the size, detail brushes are designed to go to a very fine point. The medium detail (about size 6) is the one I use most often, but the others give you increased scope. The small detail (size 3) is excellent for defining outlines and adding very fine detail. The large detail (about a size 12) holds quite a lot of paint but, like the others, still goes to a fine point.

Use detail brushes to put in trunks of trees by stroking upwards from the base.

Small detail brush

This brush can be used for small trees, adding branches to larger trees and any fine detail including adding definition to brickwork.

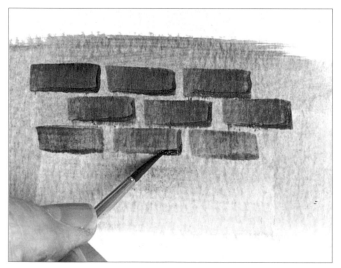

Put in the lines of brickwork using the small detail brush.

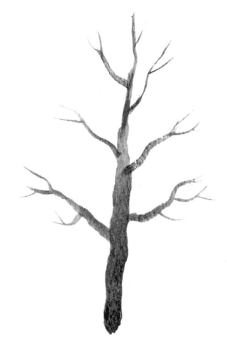

The small detail brush is ideal for painting delicate branches.

Medium detail brush

This is the brush I use most often. I usually reach for it when I want to paint trees, unless they are particularly large specimens.

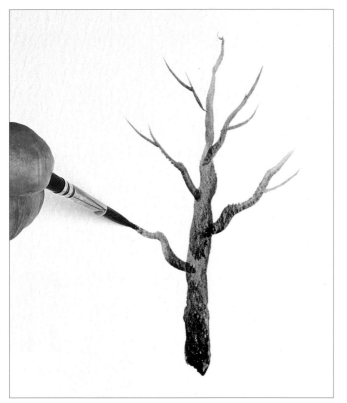

The medium detail brush still goes to a fine point that is ideal for branches.

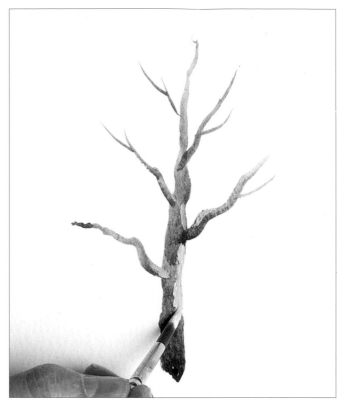

Finish the framework of the tree by adding some highlights on the sunlit side.

Large detail brush

I use the large detail brush to wash in skies or to add larger details to a landscape. The slopes of the mountain were painted using a mix of ultramarine and burnt umber, then 'snow' in a mix of white and cobalt blue was added to the peaks.

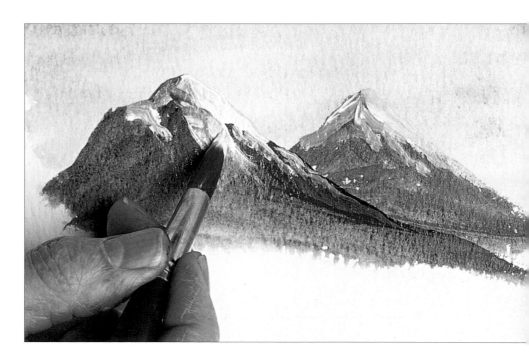

Summer Village

For this village scene on watercolour paper, I used masking fluid to produce the picket fence in the right foreground, but the fence in the middle distance was painted in using opaque white. The large expanse of road was toned down by using shadows running horizontally across, to keep the focal point at the centre of the painting.

TECHNIQUES

Big brush skies

A large brush like the golden leaf is ideal for creating dramatic sky effects very simply. You will have to work fairly quickly, but acrylic does not dry as quickly as you might expect so there is no need to rush! For these examples on canvas board, I painted the background first then, before it dried, I added the darker colours and highlights on top.

Simple sky

It is a good idea to cover the sky area with a wash first to eliminate bare patches. Some people use raw or burnt sienna, but I prefer to use cobalt blue with a touch of white – the same colour as the sky. Leave the wash to dry. In the example shown, the sun is coming from the left.

Tip

If you fix your paper to the board with masking tape, re-fix it after applying a wash to keep the paper stretched.

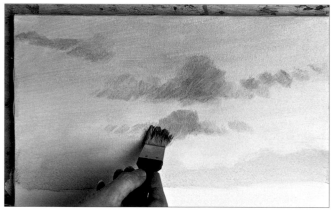

1. Apply a wash of white and cobalt blue, then apply a thicker, second wash of the same colours so that it becomes opaque. Lighten the tones towards the horizon. Paint the clouds using a dark mix of ultramarine and burnt umber.

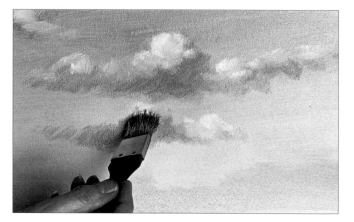

2. Rinse the brush and reload with white mixed with a touch of raw sienna. While the clouds are still wet, add highlights with light colour on the sunlit side and blend in.

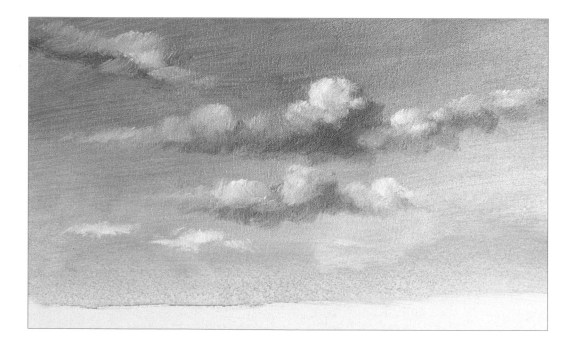

The finished sky

Stormy sky

This technique needs a bold, decisive hand. It uses the same basic technique, but the colour mix is a bit greyer! Move your brush all the time, never letting it rest on your work to avoid unsightly splodges. The dark areas are put in first, then highlighted to achieve the right effect.

1. Start by covering the surface with a wash of cobalt blue and white as for the previous example. Put in the clouds using white with a touch of raw sienna, then a grey-blue mix of ultramarine and burnt umber, adding more ultramarine in places.

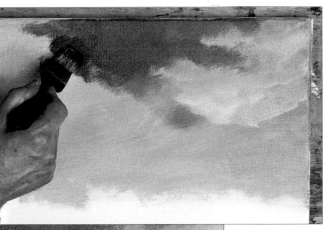

2. Use the same mixes to build up the dark tones all over the sky area first...

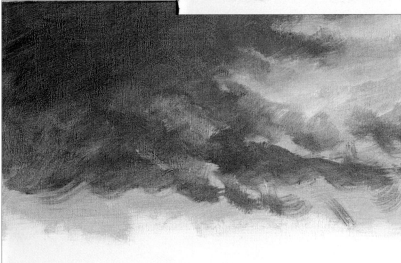

3. ...then touch in highlights of white with a little raw sienna until you achieve the effect you like.

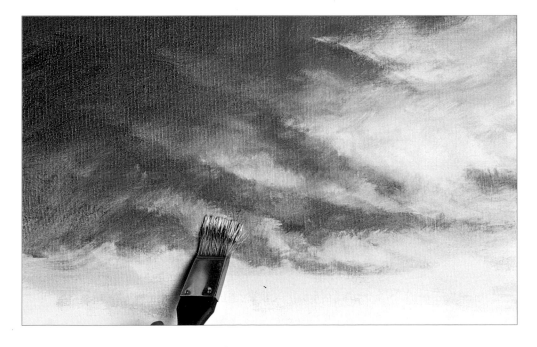

Sunset sky

For this sunset, I used canvas board but did not wash it with colour first. I put in a gradated wash using warm, red-toned colours to represent the areas of sky nearest the sun and lighter yellow tones where the sky nears the horizon.

1. Using the golden leaf brush, lay down a gradated wash with a mix of cadmium yellow and golden ochre, fading it into white at the centre where the sun will be placed. Add alizarin crimson to the same mix and blend in at the top and bottom.

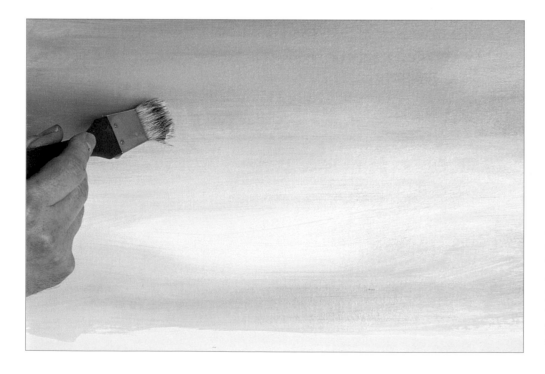

2. Using a mix of cobalt blue and white with a little alizarin crimson added, paint in the sky at the top of the painting, blending it in with the redder tones below.

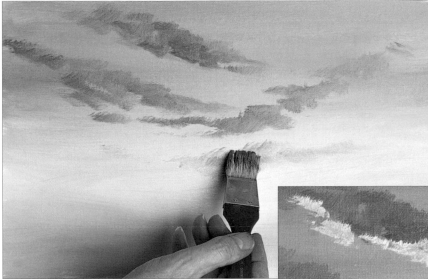

3. Using a strong mix of cobalt blue and alizarin crimson with a little white, dab in some clouds, moving in a rough 'V' shape down towards the area where the sun will be. Add just a touch of burnt sienna to the mix to put in some darker tones.

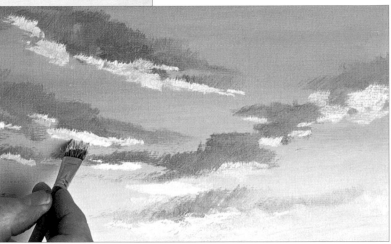

4. Using the wizard and white almost neat from the tube with just a little cadmium yellow added, touch in light colour under the clouds where the light from the sun would catch the underside.

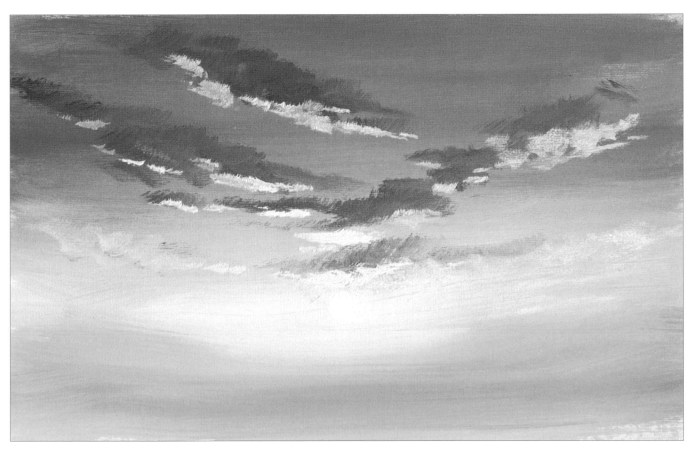

The finished sky
The sun was added using white.

Painting distance

One way to give a sense of perspective is to add a 'window' that gives a glimpse of distant fields. This simple trick uses the deerfoot stippler with a piece of scrap paper to add the field boundaries. The technique can also be seen in the snow scene on page 86.

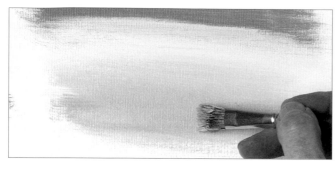

1. Paint a simple sky, then remove the white of the landscape area using a raw sienna and white mix, deepening it towards the foreground.

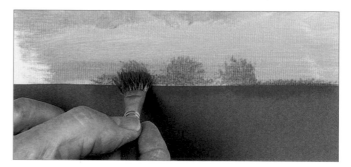

2. Using a piece of scrap paper and a mix of cobalt blue and alizarin crimson, stipple the shapes of foliage and hedgerows along the edge.

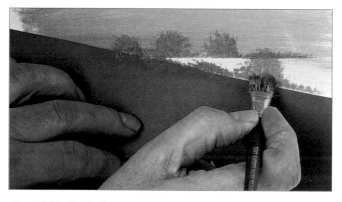

3. Add a little burnt sienna to warm the mix as the trees become closer. Reposition the paper at an angle and stipple in more trees.

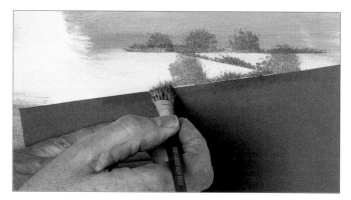

4. Add another touch of burnt sienna to warm the mix a little more, then reposition the paper and repeat the process.

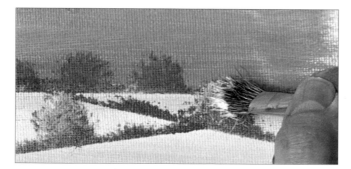

5. Add a few highlights to the hedgerows using a mix of white and yellow ochre.

The finished landscape

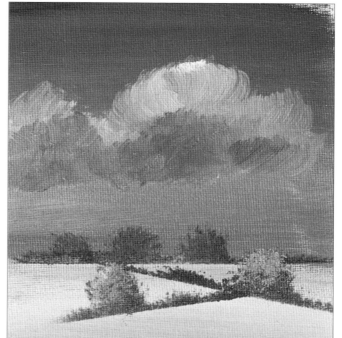

Creating depth

When I was learning to paint, I used to hear people talking about recession and aerial perspective. They said that if you make elements of a painting lighter and bluer they look further away in the distance, but I never understood what they meant! I looked in books, but I could never find anything that explained the technique. Here are some simple examples which I hope will help to remove the mystery and show you how it works!

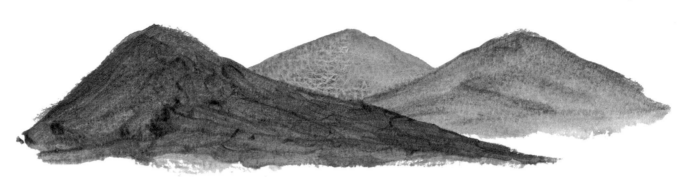

Mountains

The furthest slope was painted using the large detail brush and a mix of cobalt blue with a touch of burnt sienna. In the middle distance, more burnt sienna was added to tone down the blue, while the nearest slope has been warmed by adding more burnt sienna and a little alizarin crimson.

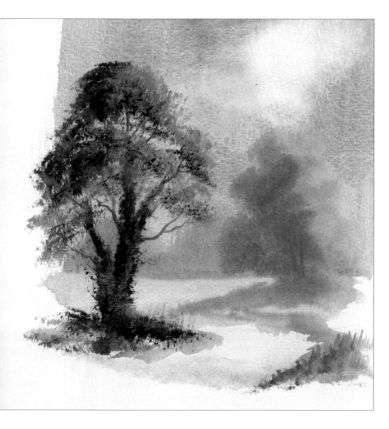

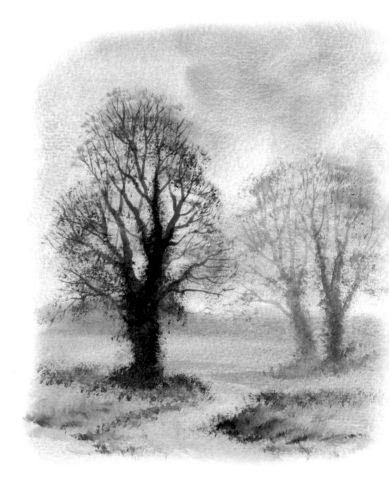

Trees

Each of these examples shows the effect that would be produced by painting a similar type of tree in the distance.

Masking fluid

Some purists dislike masking fluid, but I am not a purist and I love it!
It is never good to use anything to excess, but if it is easy and it works,
I don't see the harm. It is particularly good for adding birds to a sky, as
in the example below, which only works with 'watercolour' techniques.

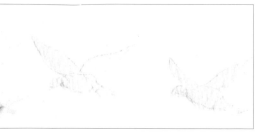

1. Draw in the shape of birds
and use a small brush to apply
the masking fluid.

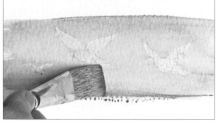

2. Using the flat brush, apply a
wash of cobalt blue over the
sky, covering the masked birds.

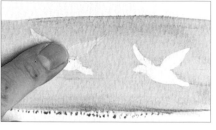

3. Leave to dry thoroughly, then
rub off the masking fluid with
the tip of your finger.

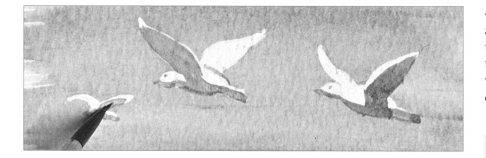

4. Using a medium detail brush
and a mix of burnt umber and
ultramarine blue, add the detail
to the birds, shading under the
wing, belly and tail. Dot in the
eye with the point of the brush.

Tip
*Coat the brush with soap
before using it with masking
fluid. Afterwards, remove the
last traces of masking fluid
using petroleum spirit
(lighter fluid).*

Gate

Masking fluid is also invaluable for details like stiles and
fences. I left the gate white, but you can apply a pale wash
over it first if you prefer, to take away the starkness. When you
dab the paint on the gate, make sure it is not too thick or it will
seal in the masking fluid and make it difficult to remove.

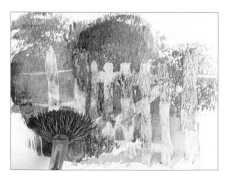

1. Mask the fence and, using the
fan gogh brush and a mix of
Hooker's green and pale olive
green, dab the paint on top.

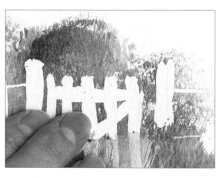

2. Allow to dry, then using your
fingertips rub off the masking
fluid and reveal the gate.

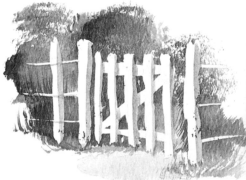

3. Paint the shadows on the
gate using a wash of cobalt blue
with a touch of alizarin crimson
and the small detail brush.

Credit card rocks

This unusual technique uses an old credit or store card to create amazingly convincing rocks. The technique works best on rough watercolour paper. The paint stays in the indentations of the surface and creates a wonderful textured effect. Draw in the shape of the rocks with soft pencil first if you find it easier. After a few practice runs you will find this technique fast and simple.

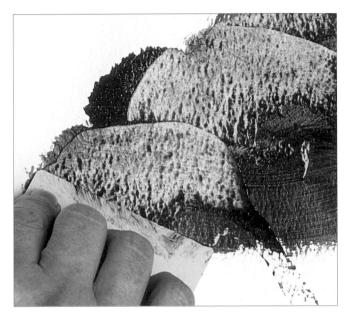

1. Using the fan gogh, dab on paint thickly in a range of brown, green and shadow colours. I used raw sienna and burnt sienna at the back, adding burnt umber, ultramarine and finally Hooker's green as I worked forward.

2. While the paint is still wet and using the edge of a plastic card held almost flat, scrape off the paint with a sweeping, circular movement. Use the edge of the card to 'draw' the edges of the rocks.

Tip

If you mess up a rock, just dab on a bit more paint and do it again.

3. Continue to work forwards, scraping off the paint with circular movements and overlapping the rocks. Hold the card at one end and put all the pressure on that end, drawing the edge of the rock with the corner of the card.

Glazing

You can change the whole nature of a painting by adding glaze, which acts like a translucent wash of colour (see page 12). It can be used over part of the painting, as in the example opposite where it has been used to add shafts of sunlight, or over the whole painting to tone it down or create a range of different effects. It is also effective for reflections (see *Monet's Garden*, page 45).

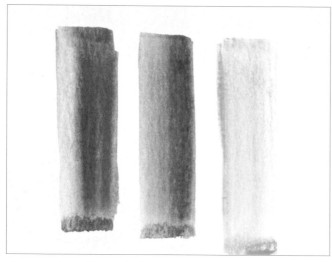

To test the effect of glazing over different colours, paint in a few bars of solid colour...

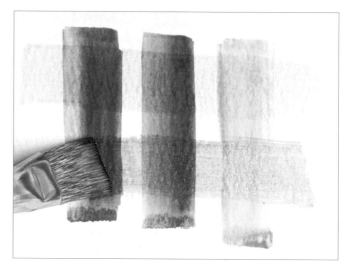

...then add a glaze – in this case cobalt blue added to glaze medium – over the top.

Winter Mooring

When this picture was completed, I wanted a warmer effect. I mixed glaze medium with a little alizarin crimson and cadmium yellow, and applied it with a large brush over most of the painting except for the boats, which needed a brighter, fresher treatment. To compare this with a similar scene at a different time of year, without the use of glaze, see pages 22–23.

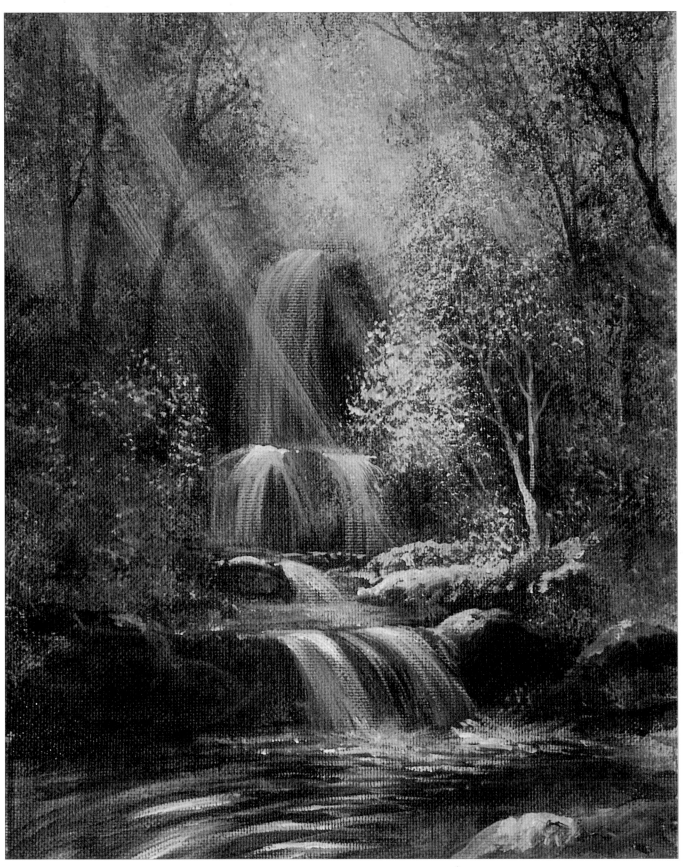

Secret Waterfall

A lot of this painting is very dark and moody. I glazed over the shafts of sunlight using glaze medium mixed with cobalt blue and a little white to produce this vivid effect.

Using knives

Acrylic paint can be used just like oil paint. Choose a thicker type of
paint or add heavy body medium to a thinner paint (see page 12). For
the example below, the mountains were painted against the backdrop
of a simple sky. For the colours of the mountains, I put quantities of
ultramarine, burnt umber, white and cobalt blue on my palette and
swirled it so they mingled in places but were not completely blended.

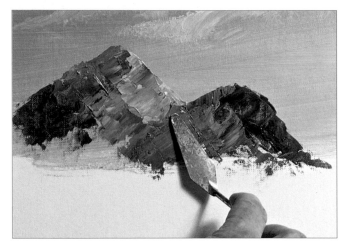

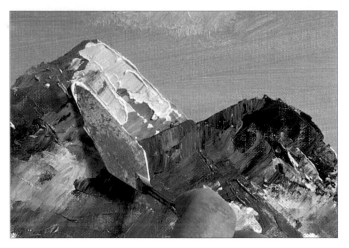

1. Starting with the darkest, pick up paint at
random from the mixes on the palette. Lay them
on very thickly with the palette knife. Do not work
over the paint too much or it will start to blend.

2. Pick up white paint and add it to the tops of
the mountains.

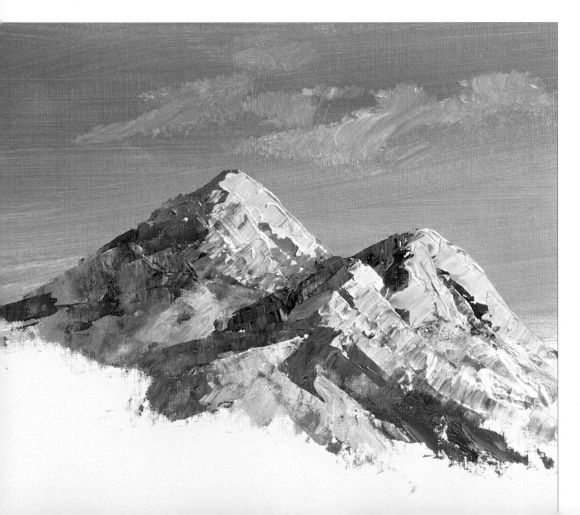

3. Build up the paint
layer on layer until you
are happy with the
effect. For the slopes in
the foreground, use
warmer mixes with
raw sienna added to
bring them forward.

Silver Birch

These lovely trees are among my favourites. They may look difficult, but this simple acrylic technique gives a stunning effect. The paint remains workable for quite some time, so you can 'fiddle' until you get it right.

1. Load white paint along the edge of the knife.

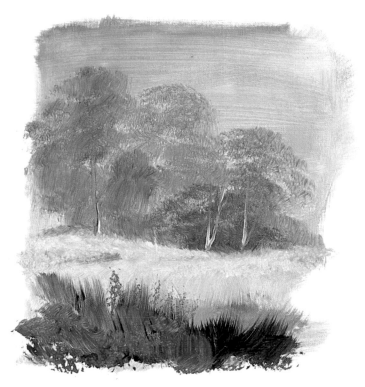

The background for the tree

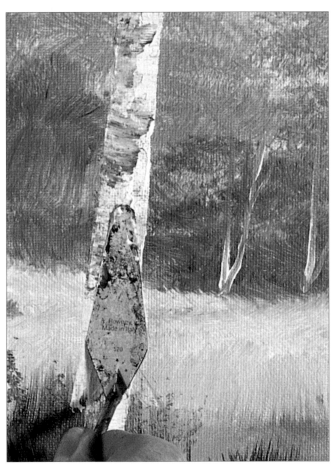

2. Hold the blade of the knife upwards and using horizontal strokes, lay the paint on the trunk. Dab a mix of ultramarine and burnt umber into the white to vary the tones.

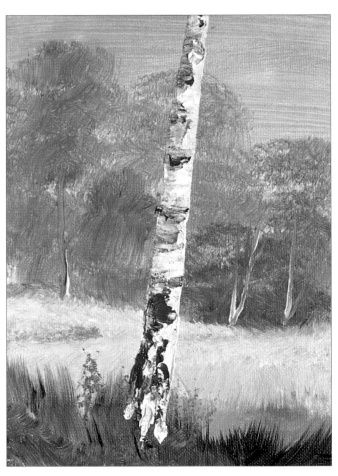

3. Add touches of a darker mix of ultramarine and burnt umber at the base of the tree, where the bark splits and reveals a darker colour.

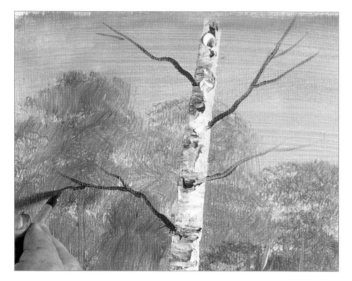

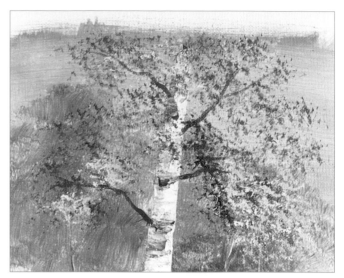

4. Paint in the branches using a medium detail brush and a mix of ultramarine and burnt umber, noting that some branches come from the knots.

5. Squeeze out a golden leaf brush and make sure the bristles are open, then stipple a dark wash of Hooker's green over the tree.

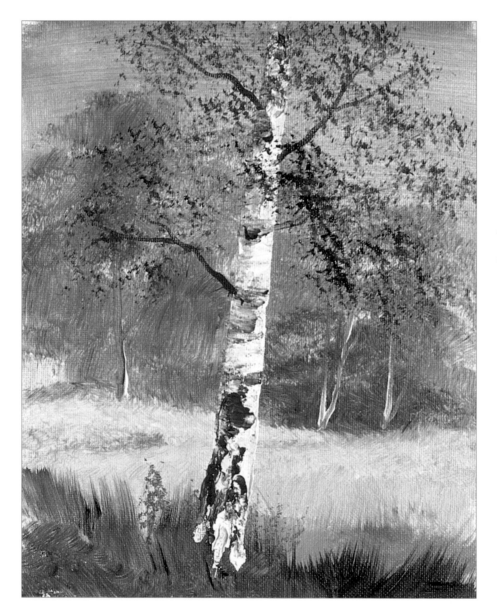

The finished picture
Highlights have been stippled in with pale olive green and cadmium yellow.

Opposite
Silver Birches
The trees in this picture have been put in using the palette knife method – see page 69. A simple method of painting bluebells is shown on page 80.

70

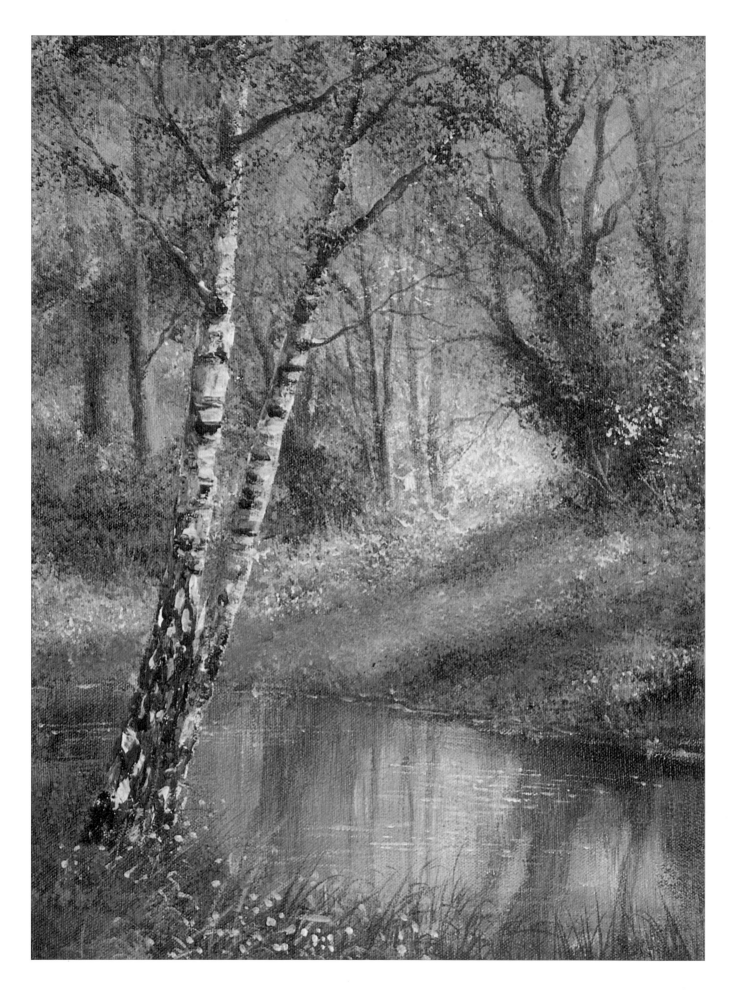

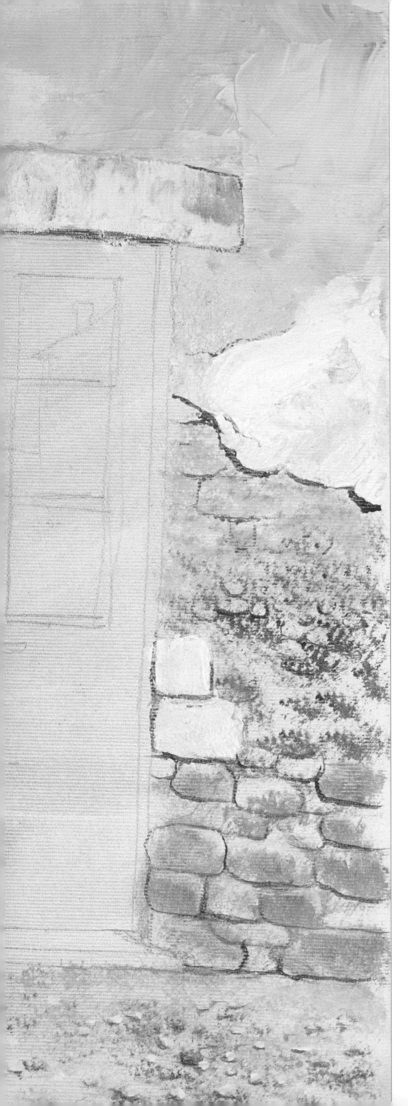

Textures

If you want to include buildings in your paintings, it is important to look at the textures you find on them. Convincing brickwork, stone, pebble-dash, flint or stucco effects can be painted using watercolour techniques, but acrylic gives you an extra advantage. It allows you to build up *real* textures on the surface of your work using techniques ranging from stippling with thick paint to laying it on with a palette knife.

Doorways make attractive pictures in their own right and are a good introduction to painting textures. In this example, the many textures on a crumbling Mediterranean-style building are recreated. Start with a background wash of pale raw sienna.

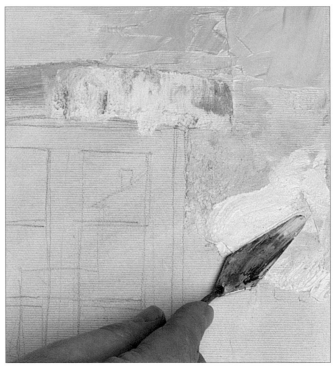

1. Using a palette knife and a mix of white with a little raw sienna to take off the starkness, start to build up the texture of the door lintel and the crumbling wall.

Tip
Some artists add extra texture by mixing sand and other substances with their paint. I do not do this, but experiment if you like!

2. Using the foliage brush, stipple raw and burnt sienna over the wall area to add some different textures.

3. Change to a mix of cobalt blue and burnt sienna lightened with white and dab on the tones of the brickwork.

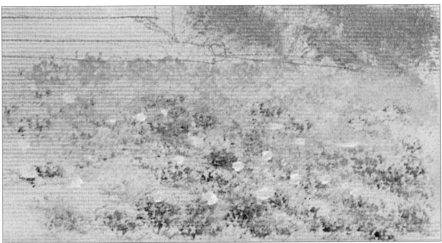

4. Dab on the foreground texture using the foliage brush and mixes of raw and burnt sienna. Add the stone shapes using the small detail brush and white with a little cobalt blue added.

5. Add stones using white with a little raw sienna and one sweep of the flat of the palette knife.

6. Using the small detail brush and a mix of ultramarine and burnt umber, paint the shadows under the textured areas of wall.

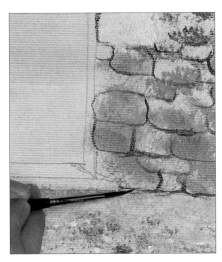

7. Using the small detail brush and the same paint mix, outline rectangles for the brickwork.

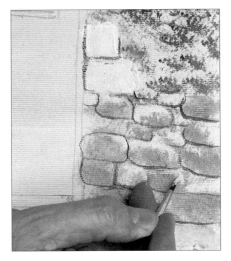

8. Still with the small detail brush and using a mix of white with a little raw sienna, highlight the sunlit top edges of the bricks.

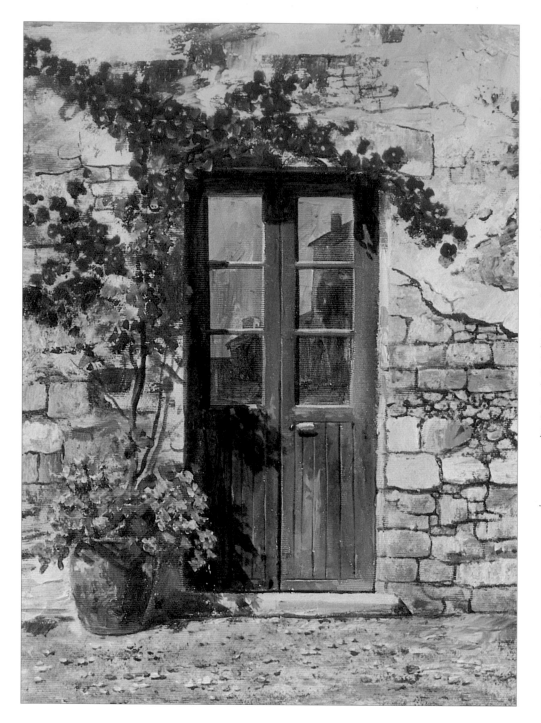

The finished painting

The example shown on the previous pages was developed into this painting. Mixes of raw sienna were added to tone down the various areas of texture on the walls. The arch of flowers was painted using the medium detail brush and mixes of alizarin crimson, permanent rose and white, and the geraniums were painted with permanent rose and white. The door was painted using the medium detail brush and mixes of Hooker's green with small amounts of cobalt blue, raw sienna and white added to produce the chalky appearance of old, sun-scorched paintwork.

Opposite
The Breakfast Terrace

The walls in this picture were painted using the techniques shown on pages 72–73. The bright blue pots filled with flowers in mixes of alizarin crimson and permanent rose lead the eye up the steps and on to the terrace.

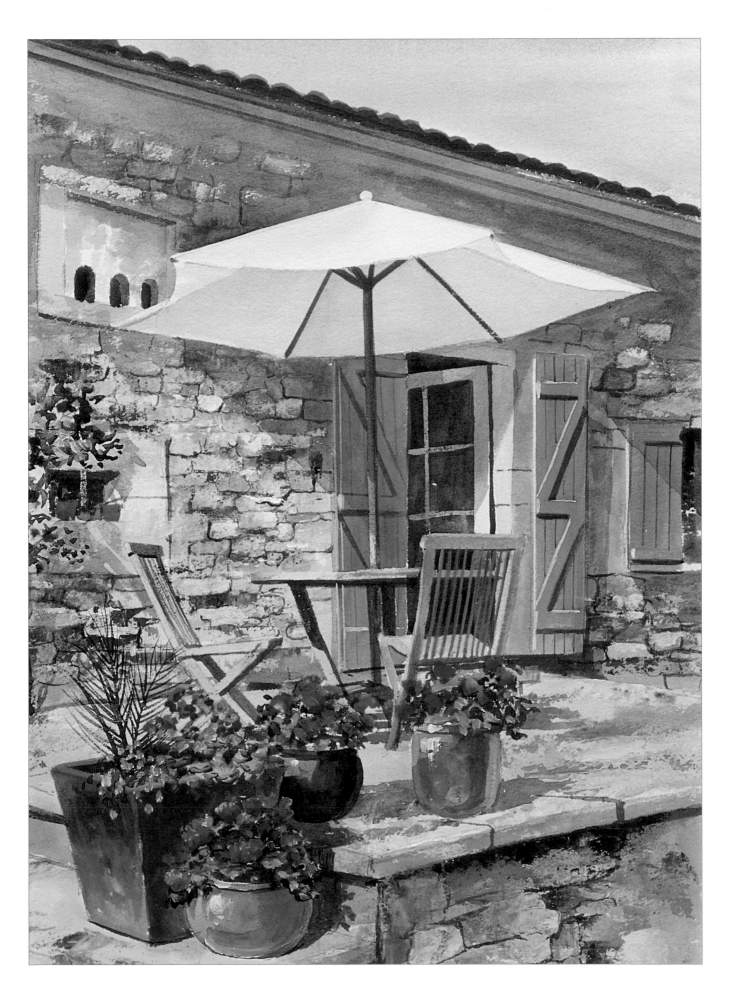

Adding life

No matter how much effort you put into a painting, sometimes the result just looks a little flat and uninteresting. This is especially true of landscape paintings. This is when I call upon my secret weapon, my armoury of extra finishing touches. Adding a few sheep or geese, or a detail such as a stile or a postbox, can make all the difference. A few are shown in this section; others can be found in the paintings throughout this book. Carry a sketch book around at all times and make quick sketches of your own. Your paintings will never lack interest!

Overleaf
Scottish Harbour
This picture of a tiny Scottish harbour is very detailed and the houses, boats and people were mainly painted using small and medium detail brushes. The foliage brush was used for the leaves on the trees and the texture on the stonework of the quay, while the rocky outcrop in the middle distance was put in using the 'credit card rocks' technique (see page 65).

DEMONSTRATIONS

Bluebells

Paintings of bluebells are always popular, and wherever I go I am asked for tips on how to paint them. I think they are popular partly because they have such a short season, and also because they look so beautiful in the woods but you cannot really take them home. These suggestions should help you to capture their beauty. For this example, I used canvas and just three brushes: the golden leaf, the medium detail and the foliage.

You will need

Prepared canvas about 39.5 x 29cm (15½ x 11½ in)

2B pencil

Brushes: golden leaf; medium detail and foliage

Paints: my basic palette (see page 14)

1. Using the golden leaf brush and a mix of cobalt blue and white, paint out the white of the paper. Draw the outline on top of this first wash: unlike watercolour, acrylic tends to cover drawing done first. Put on a deeper wash of cobalt blue and white, then add a little burnt sienna and white for the path and a few touches to suggest contours.

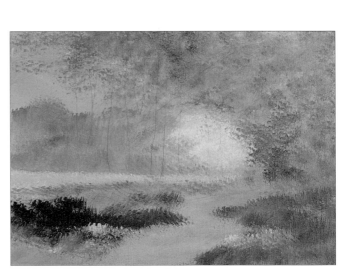

2. Still using the golden leaf brush, paint a light area using a mix of white and cadmium yellow. Dab on some cobalt blue, then some cadmium yellow, then pale olive green and finally some Hooker's green for the foliage. Block in tones for the foreground foliage using various mixes of green, including a mix of Hooker's green and ultramarine for the darkest tones.

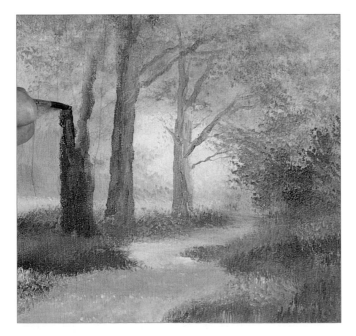

3. With the foliage brush, dab in the path using a mix of raw sienna and white. Paint in the tree trunks and larger branches using the medium detail brush and Hooker's green, then darken the foliage in some areas using various mixes of Hooker's green and ultramarine.

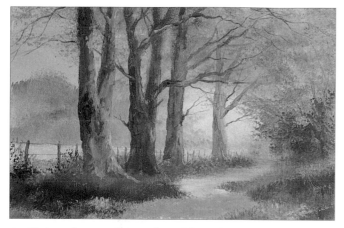

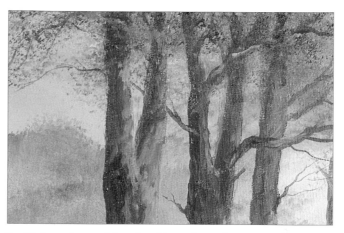

4. Using the medium detail brush and various mixes of green, finish the trees and add the fence. Note that the trees are more green than brown.

5. Using the golden leaf brush and a mix of Hooker's green, pale olive green and white, stipple over the trees to soften the outlines.

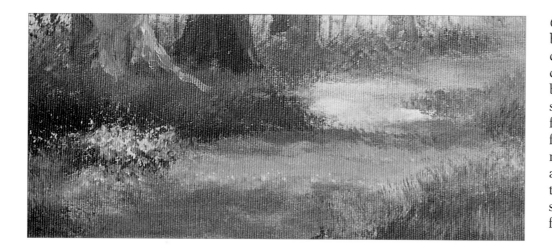

6. Using the foliage brush and a mix of cobalt blue, alizarin crimson and a touch of burnt sienna, put in the shading on the footpath. Using the foliage brush and a mix of yellow ochre and white, add some texture and patches of sunlight to the footpath.

Tip

Always add bluebells to your painting last, putting them on top of a background of foliage – never leave gaps in the foliage.

The mixes left are useful for painting bluebells.

Top: white mixed with cobalt blue

Middle: white, cobalt blue and alizarin crimson

Bottom: mixes of white, cobalt blue and alizarin crimson against foliage colours of pale olive green and Hooker's green

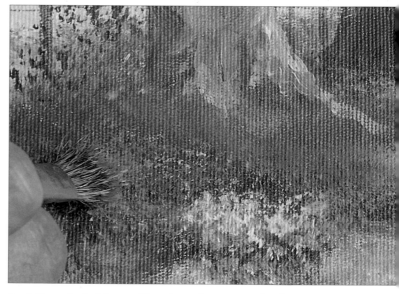

7. Mix cobalt blue, alizarin crimson and white in different quantities and concentrations to vary the shades and tones. Using the tip of the bristles on the foliage brush, pick up tiny amounts of colour and dab it on to your painting in drifts.

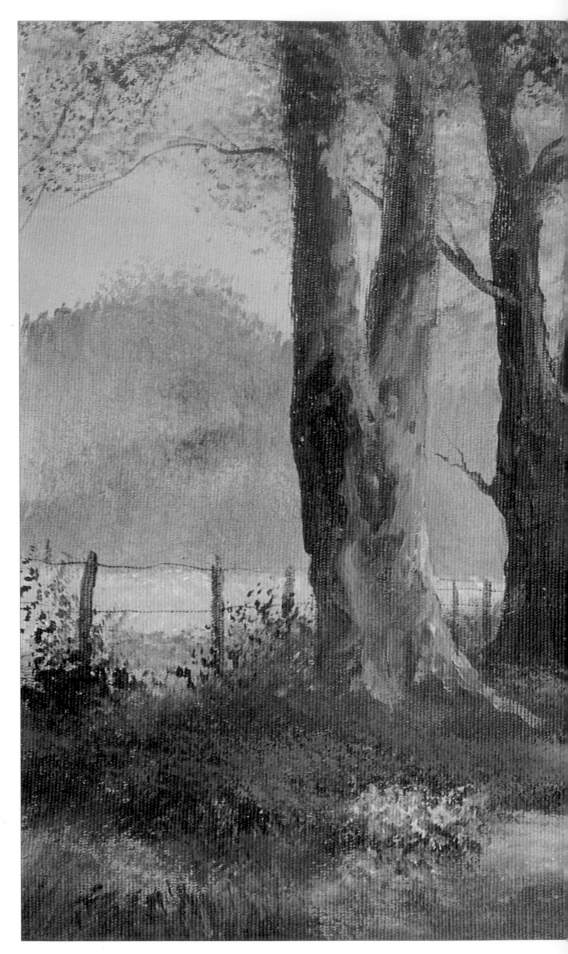

The finished painting
I used lighter tones for the bluebells where shafts of sunlight fall on them.

The Towpath Gate
This was a fairly uninteresting view, but I added drifts of bluebells and managed to change the whole feeling of the painting.

Snow Scene

This snow scene on canvas board makes use of several devices to draw the viewer's eye into the painting. The light area where the sun is forms almost a 'V' shape, while the trees arch over to frame a picture of fields receding into the distance. Do not be afraid of overlapping the background trees when you paint in the foreground tree, because it will help to bring it forward.

You will need

Canvas board about 61 x 41cm (24 x 16in)
2B pencil
Piece of scrap paper
Brushes: golden leaf; fan stippler; fan gogh; half-rigger; wizard; large, medium and small detail
Paints: my basic palette (see page 14)

1. Using a 2B pencil, sketch in the main outlines of your composition. Using the golden leaf brush, apply a wash of burnt and raw sienna to the whole, adding a touch of white to make it lighter towards the centre and varying the intensity, to give an overall warm effect.

Tip
At an early stage in your painting, work out what direction the sun is coming from so you can plan the shadows and highlights.

2. Put in the light area for the sun using a mix of cadmium yellow and white, warmed with a touch of alizarin crimson. Add more alizarin crimson towards the horizon. Put in the clouds with a mix of cobalt blue, alizarin crimson and burnt sienna.

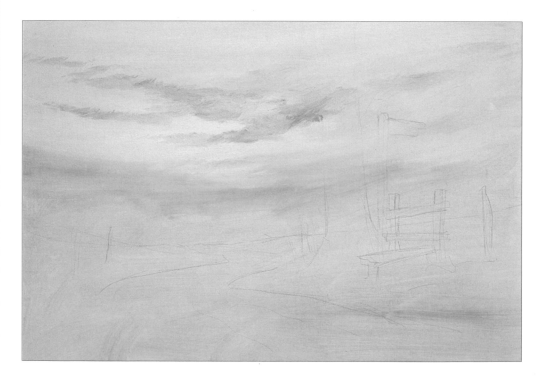

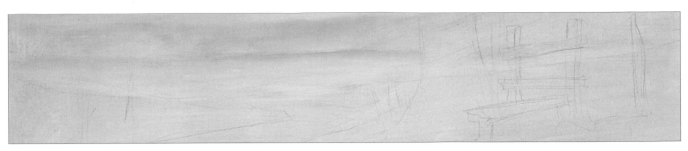

3. Using a mix of cobalt blue and white, put in the horizon. Add more white to the mix as you come forward to paint in a background for the fields.

4. Angle a piece of scrap paper on your painting. Using the fan stippler and a mix of cobalt blue, alizarin crimson and a little white, stipple in the hedgerows. Darken the mix by adding more alizarin crimson and a touch of burnt sienna towards the front to give a feeling of recession.

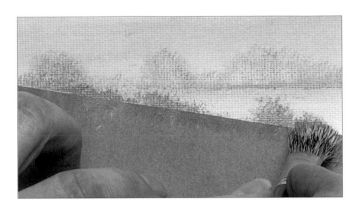

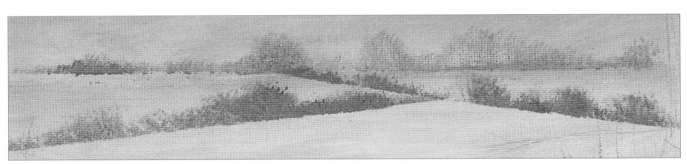

The completed hedgerows

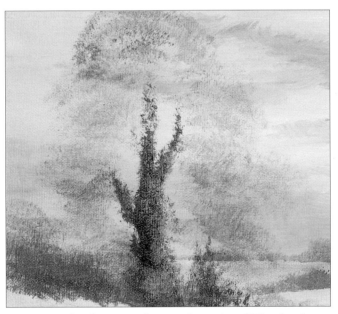

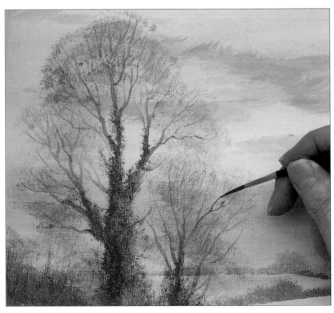

5. Using the fan stippler and a mix of Hooker's green and ultramarine, put in the ivy-clad tree. Using the same brush and a mix of burnt sienna and cobalt blue, dab in the canopy of twigs.

6. Using the half-rigger and a mix of burnt sienna and cobalt blue, put in the network of branches.

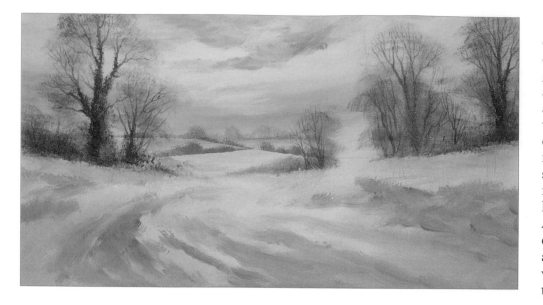

7. Add more trees to complete the middle distance. Using the golden leaf brush and a mix of cobalt blue, alizarin crimson and white, put in the tones of the snow. Keep the front central area dark so the centre of the middle distance looks lighter in comparison. Add a few touches of a cadmium yellow and alizarin crimson mix where the sun highlights the ridges of the track.

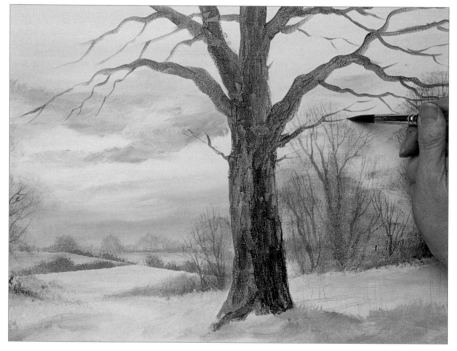

8. Paint in the large tree using the large detail brush and a mix of Hooker's green and burnt umber, adding ultramarine to the mix for the shady part.

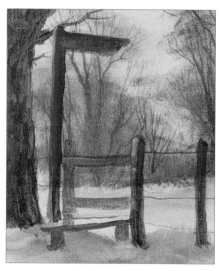

9. Paint in the stile and fence posts using the large detail brush and a mix of ultramarine and Hooker's green. Using the half-rigger and the same mix with a little burnt umber added, add the wires to the fence.

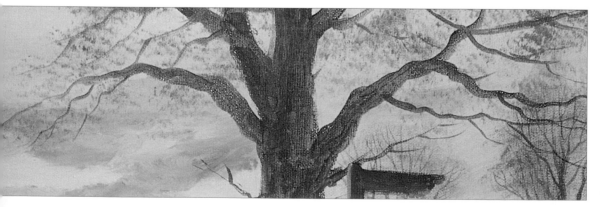

10. Using a mix of cobalt blue and alizarin crimson and the golden leaf brush, making sure the bristles are well opened up, stipple over the branches of the large tree to stop them looking so stark.

11. Using the medium detail brush and white with a touch of cobalt blue, lay snow on top of the branches. Use the half-rigger for the really tiny ones.

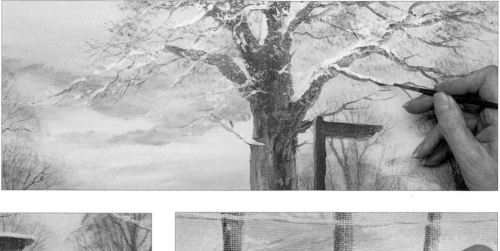

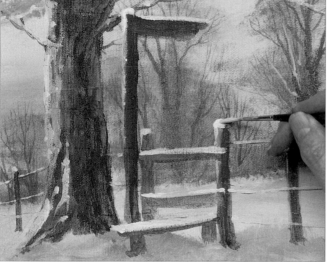

12. Using the small detail brush and a mix of white with a little cobalt blue, paint in the snow on the stile and along the top of the fence.

13. Using the fan gogh brush and a mix of burnt sienna, flick up to create grass. Add some burnt umber and turn the brush sideways to add ferns.

14. Using the half-rigger, paint in some fine grasses in burnt umber, then highlight them in white.

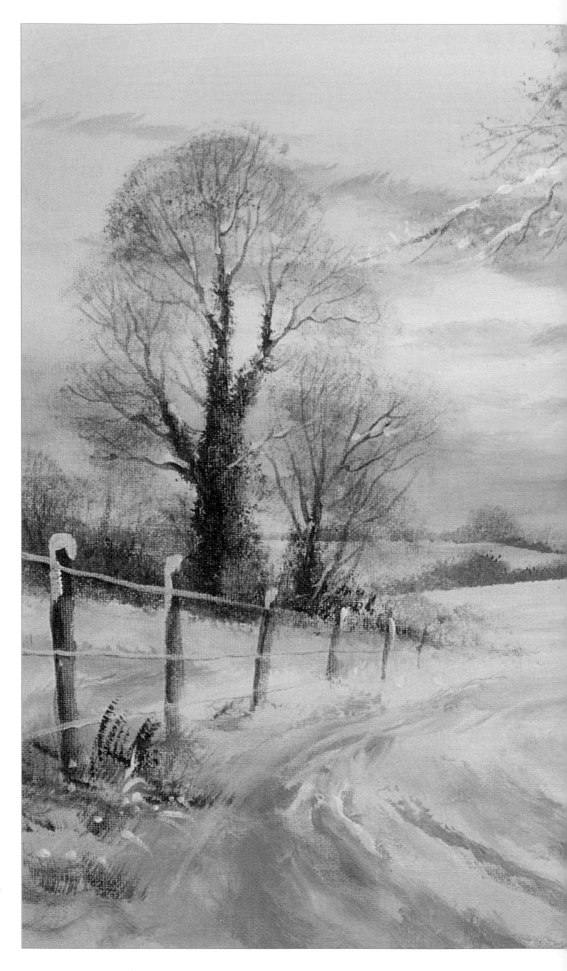

The finished picture
The cart tracks were added using the wizard brush and a mix of burnt umber and ultramarine with a touch of alizarin crimson.

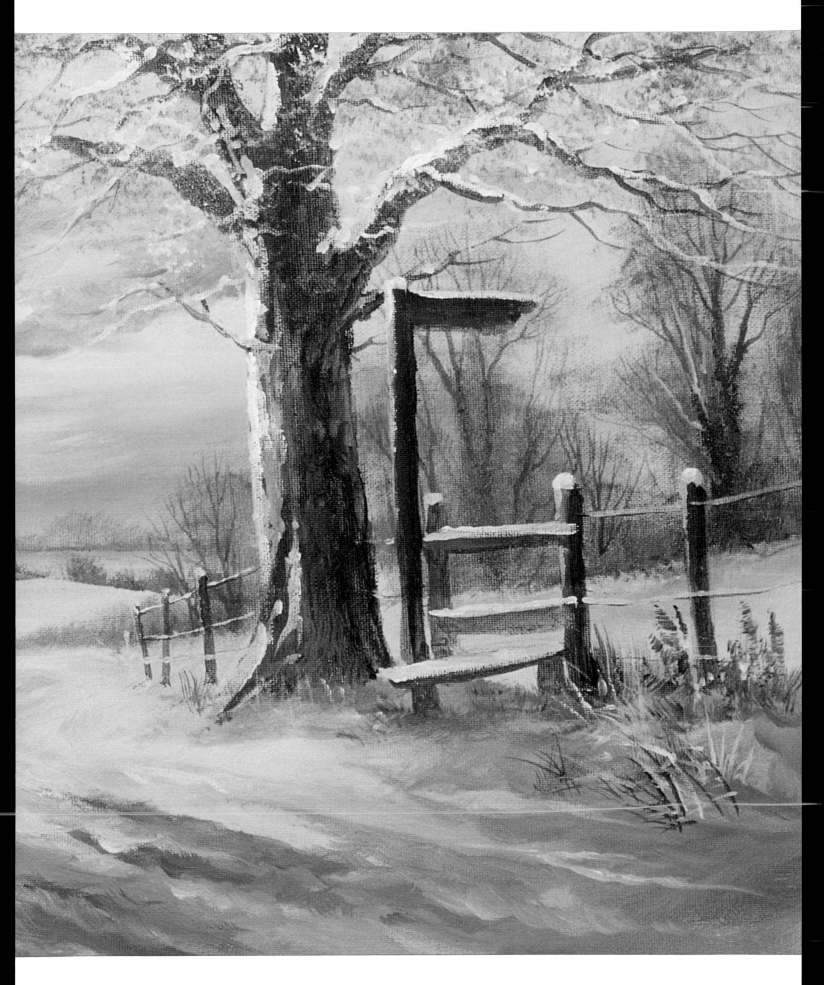

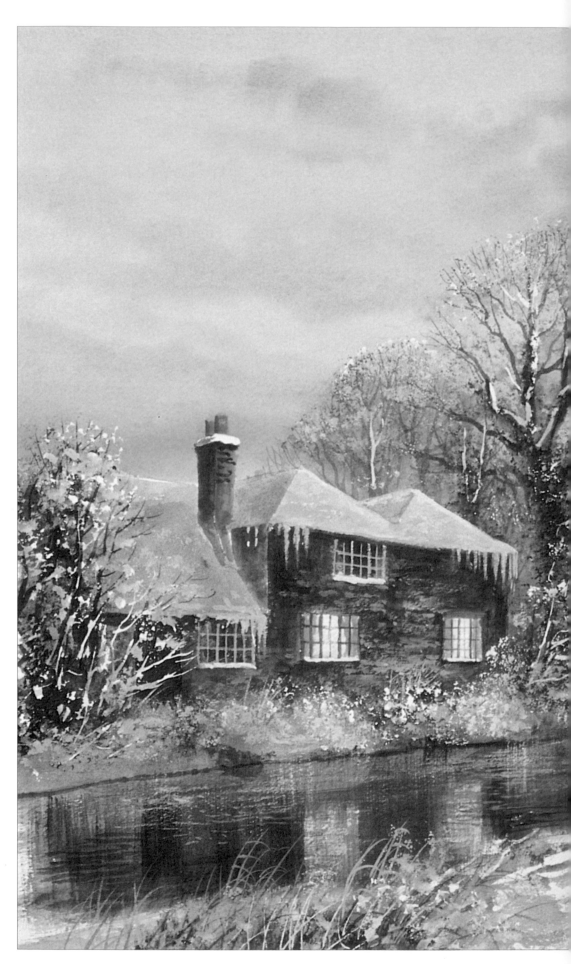

Winter Light

This painting uses the same techniques as in the preceding project, but the house adds a different element. Its welcoming lights are reflected in the stretch of water.

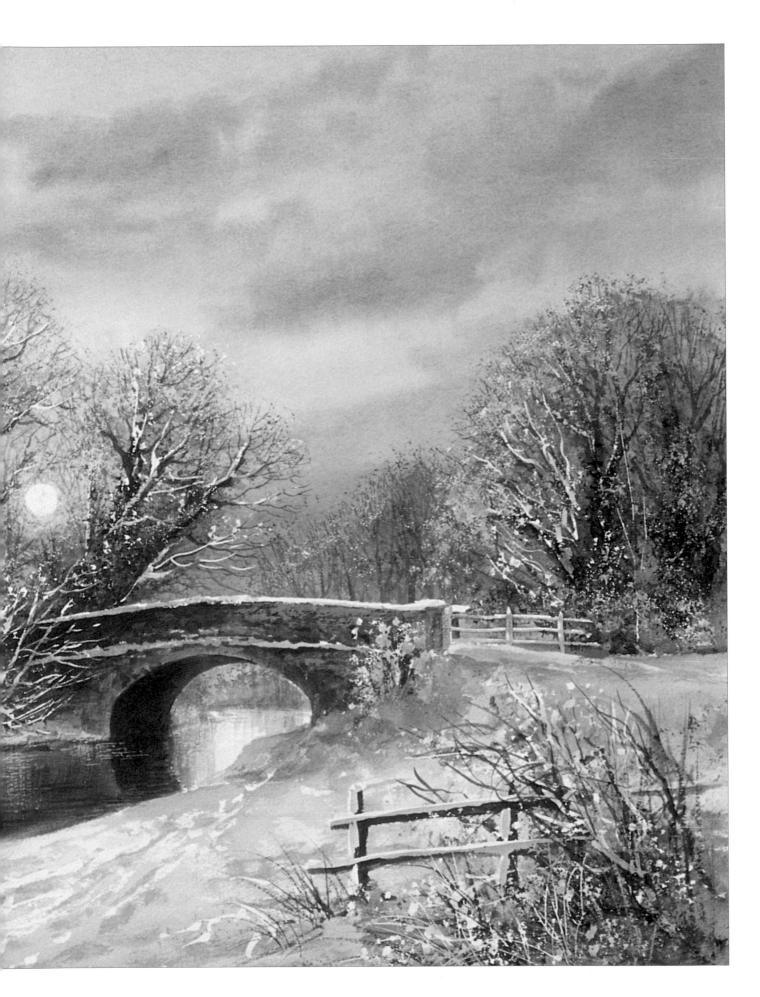

Waterfall and Rocks

This simple project on watercolour paper uses the credit card rocks technique shown on page 65. The foliage was put in loosely and simply using the foliage brush and light, bright mixes of green and yellow, with blue added to give a sense of perspective. The warmer tones used for the rocks makes them stand out in the foreground, giving an effect that is almost three-dimensional.

You will need

Rough watercolour paper 56 x 38cm (22 x 15in)

2B pencil

Old plastic credit or store card

Brushes: golden leaf; fan gogh; foliage; flat; large, medium and small detail

Paint: my basic palette (see page 14)

1. Draw in the rough shapes of the rocks on watercolour paper.

2. Put in the background colours using the golden leaf brush, stippling on mixes of light cadmium yellow and pale olive green. Stipple over the top with Hooker's green. Add touches of cobalt blue in places to create the effect of recession.

3. Still using the golden leaf brush and the same colour mixes, plus burnt sienna to bring them closer, put in some grasses in the middle distance. Using the credit card technique on page 65, add the rocks using shades of brown, green, blue and shadow mixes of ultramarine and raw and burnt sienna.

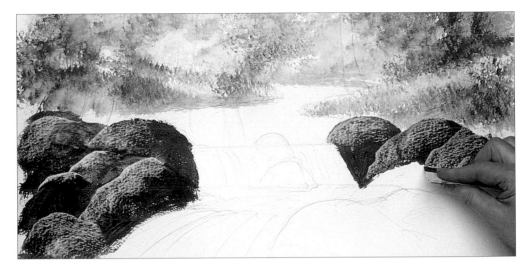

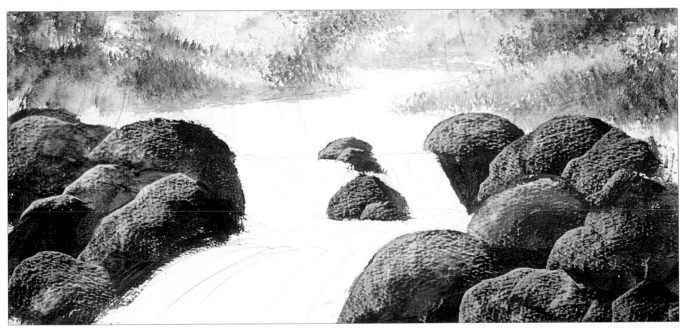

The completed rocks

4. Put in the tree trunks on the right using the large detail brush and a mix of Hooker's green and burnt umber, deepening the tones on the shadowed side of the trees. Add the branches using the same mix of colour and the medium detail brush.

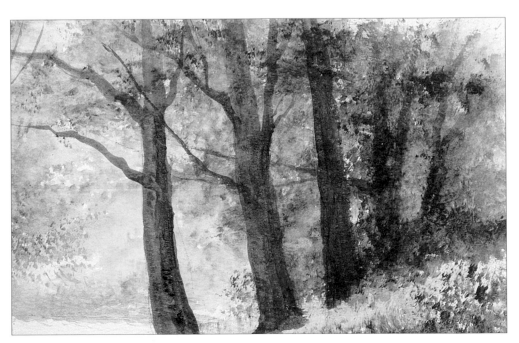

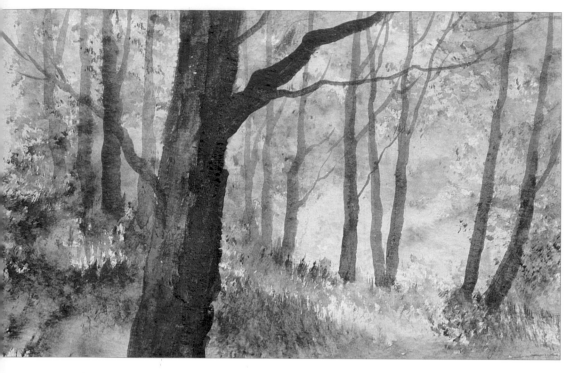

5. Add some more trees to the left-hand side of the painting, using the large and medium detail brushes and a mix of Hooker's green and burnt umber, deepening the tones as before on the shadowed side of the largest trees.

6. Using the flat brush and the colours used above, put in the grass and sky reflections in the water. Use downward strokes first, then using the brush fairly dry, work across the reflections again to create ripples.

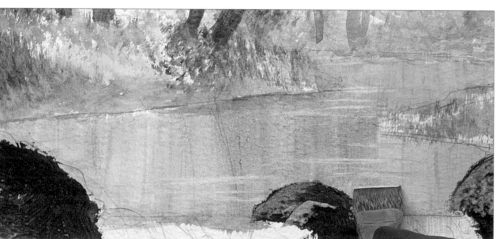

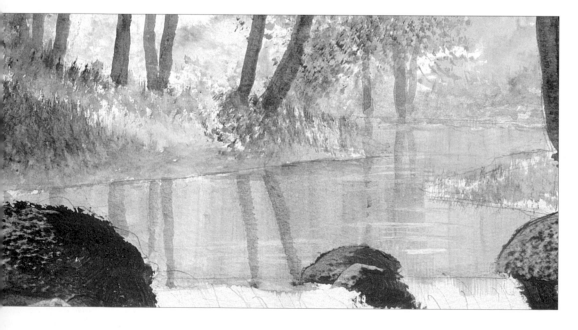

7. Using the medium detail brush and the colours used for the trees above, put in the reflections.

8. Using the fan gogh and mixes of Hooker's green, pale olive green and burnt sienna, put in the grasses at the edge of the water, adding reflections where appropriate.

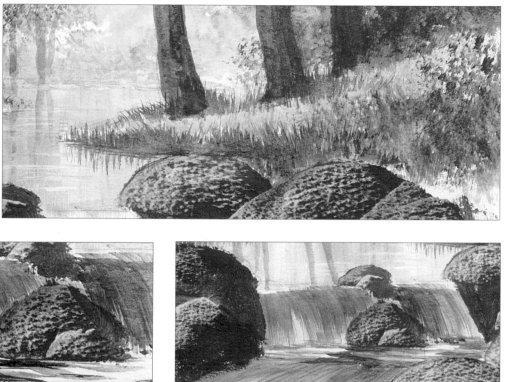

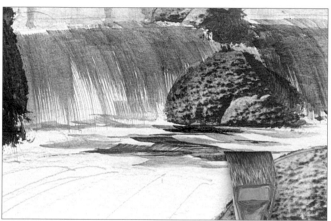

9. Using the flat brush and a mix of ultramarine and burnt umber, put in the first fall of water. Using Hooker's green and ultramarine, put in some slightly darker tones underneath.

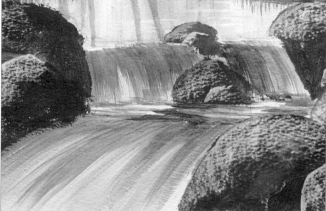

10. Still using the flat brush fairly dry, and a mix of Hooker's green, cobalt blue and raw sienna, stroke in the next fall of water.

11. With the same brush, stroke on a wash of cobalt blue.

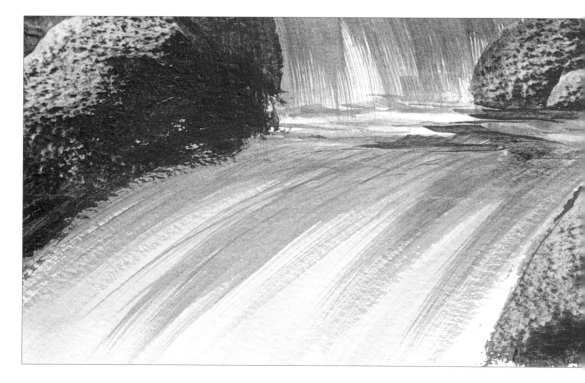

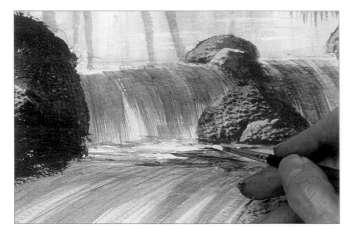

12. Using the small detail brush and plain white paint, add splashes of foam to the waterfall and some ripples beneath.

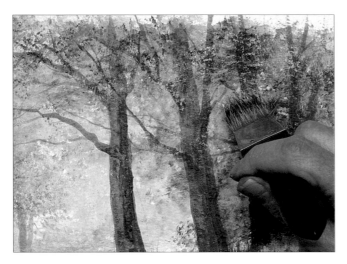

13. Using the golden leaf brush and a mix of white with pale olive green, stipple the sunlit areas of the foliage. This also helps to soften the starkness of the trees.

The finished painting

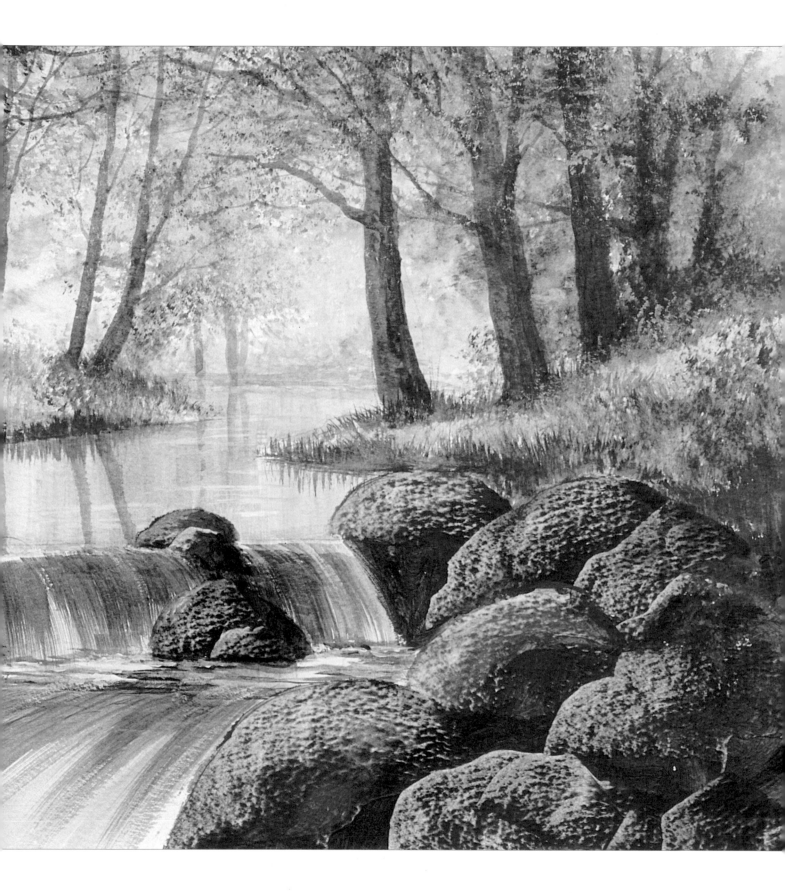

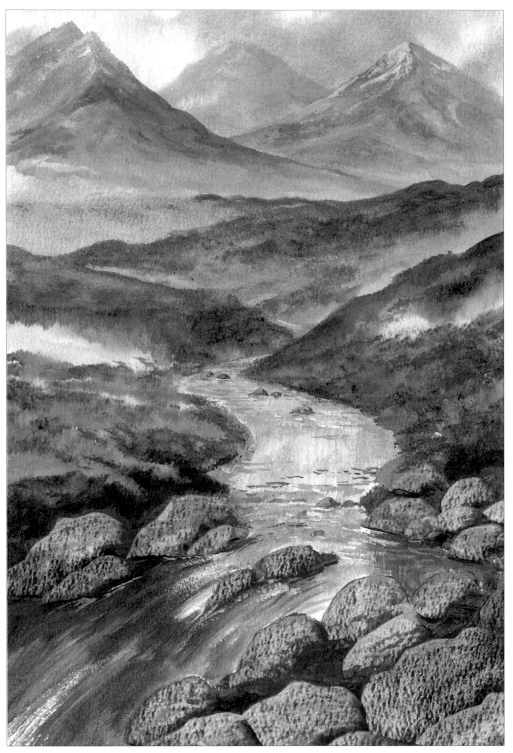

Highland Water

This painting on rough watercolour paper was built up in different layers coming forward, with the colours used becoming progressively warmer towards the foreground. The rocks were put in using the credit card technique – see page 65. The water was put in using the flat brush, with streaks added using the wizard at the front to give movement.

Opposite
Crashing Waves

The focal point here is the dramatic spray of water, which was created using the foliage brush and mixes of white, ultramarine and burnt umber. It was stippled over using the fan stippler and white to add the spray. The light spray and ripples contrast with the dark, brooding sky, the deep tones of the water and the dramatic rocks. The sand in the foreground was glazed over using white and cobalt blue to produce the effect of still water.

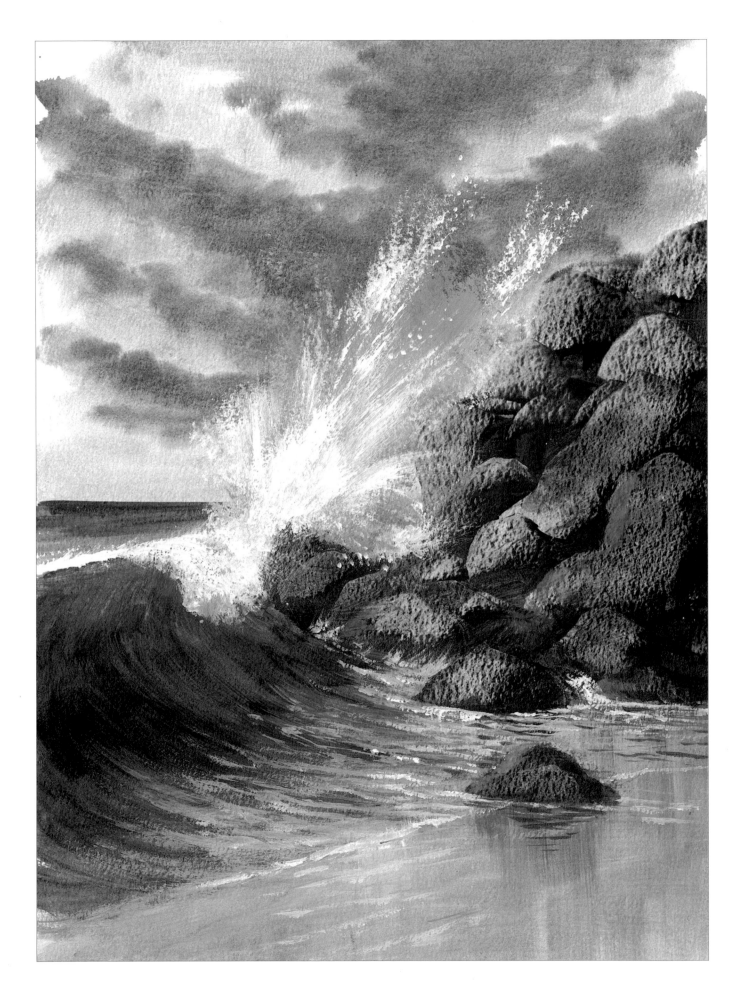

Mountain Scenery

This project is on canvas, and makes full use of the palette knife technique described on page 68. Playing with the palette knife is the fun bit: paint the mountain in layers coming forward, adding colours and tones by eye. You can follow a photograph or make up your own mountain – no-one will know!

Use a thicker acrylic paint for this painting, or add heavy body medium to thicken up a more liquid paint – see page 13.

You will need

Prepared canvas about 39.5 x 49.5cm (15½ x 19½ in)

2B pencil

Palette knife

Brushes: wizard; golden leaf; flat

Paints: my basic palette (see page 14)

1. Sketch in the outlines of the scenery lightly. Take the starkness off the canvas with washes of cobalt blue and white, and raw sienna and white.

2. Using the golden leaf brush and a mix of ultramarine with a touch of alizarin crimson and a little burnt umber, put in the sky, then use some raw sienna and white to increase the coverage in the foreground.

3. Using the wizard brush and a mix of burnt umber and ultramarine, block in colour as a background for the palette knife techniques you will use to build up the mountains.

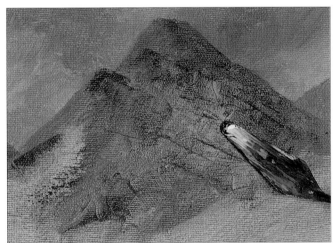

4. Using the palette knife and a mix of ultramarine and burnt umber, start to put in the contours of the mountain. Add a little white to the same mix as it comes forward.

5. Still using the palette knife, add some raw sienna to the mix and keep building up the contours and tones. Add in some darker areas to create different textures on the rocks.

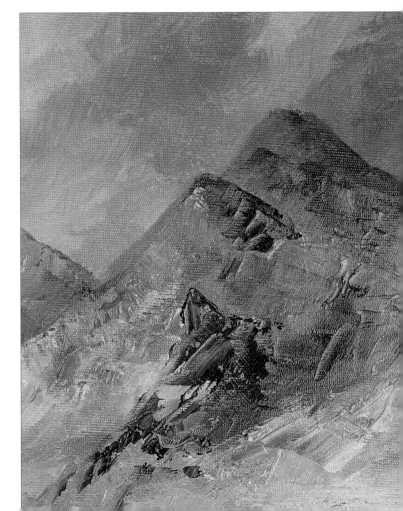

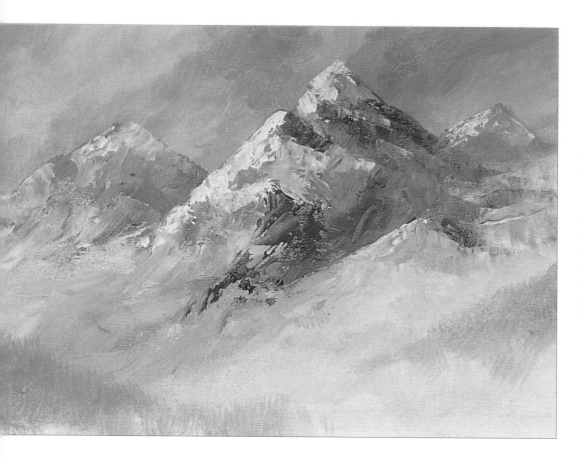

6. Still using the palette knife, add snow to the tops of the mountains using white with a touch of cobalt blue added. With white only, highlight the sunlit snow on the left of the mountain. Change to the golden leaf brush and paint in the foothills using a mix of raw sienna and white, then add some cobalt blue and burnt umber to the mix and put in some more contours.

7. Still using the golden leaf brush and a mix of Hooker's green with touches of white and cobalt blue, put in the suggestion of fir trees for the forested lower slopes.

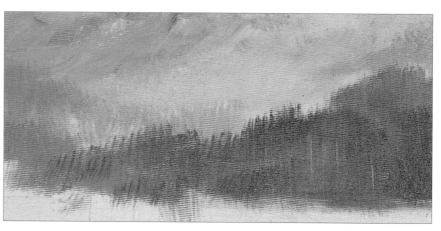

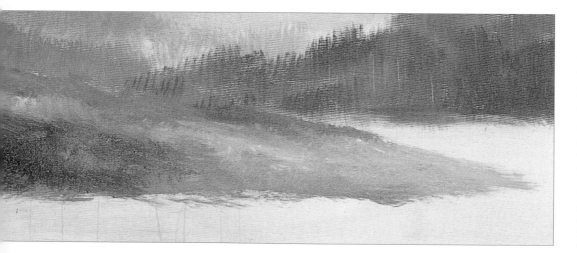

8. Still using the golden leaf and a mix of burnt sienna, burnt umber and white, put in the headland. Use a dabbing movement, and change tones by adding a little ultramarine in places. Towards the front, add some Hooker's green and some touches of pale olive green and yellow ochre.

9. Using the flat brush and the colours used for the trees, start to paint the lake by putting the reflections of the firs into the water. Stroke the brush downwards first, then turn work over the area again with the edge to create a ripple effect. Work forward, adding a mix of cobalt blue, white and raw sienna. Blend with the reflections and break up with horizontal brush strokes.

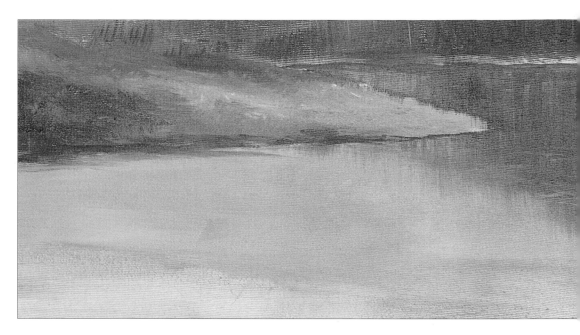

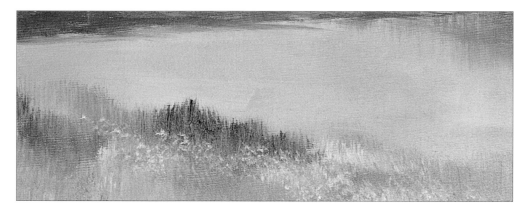

10. With the golden leaf brush put in clumps of foliage at the edge of the water in the foreground, stippling in varying mixes and tones of raw sienna, Hooker's green, pale olive green and white.

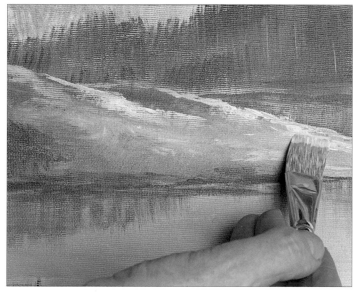

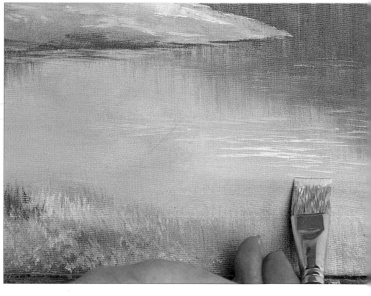

11. Using the flat brush, put in the reflections under the bank on the left with a few downward strokes. Touch in highlights of raw sienna and white on the top of the headland.

12. Using the flat brush held horizontally, put in a few ripples with a mix of white and a little cobalt blue.

The finished painting
The golden leaf brush was used to stipple over the foreground foliage in white and pale olive green.

Highland Scene
These gentler slopes were painted with the large detail, and the medium detail was used for the foreground rocks. The field grass was painted with the foliage brush and the fan stippler.

Poppy Field

This painting on canvas board is my favourite subject, the landscape. There is plenty of interest in the far and middle distance, while the path and the stile in the foreground lead the viewer's eye into the painting. The poppies were painted last and I deliberately kept them to a minimum. You can add more if you prefer, but in my experience, if you put in too many poppies it does not look realistic.

I started by drawing the outlines of the scene on canvas board. If you find that these pencilled lines are covered by your first washes, they can be drawn in again. You will not need to rub them out – when the painting is finished they will be completely covered.

You will need

Canvas board 61 x 45.5cm (24 x 18in)
2B pencil
Scrap paper
Brushes: golden leaf; small, medium and large detail; foliage; deerfoot stippler; fan stippler; half-rigger
Paints: my basic palette (see page 14)

1. Draw in the outlines of your painting. Using the golden leaf brush and mixes of cobalt blue and white for the sky and raw sienna and white for the lower half, roughly block in the colours.

2. Dab a thicker mix of cobalt blue and white across the sky so that it covers the undercoat. Mix white and raw sienna and add the clouds.

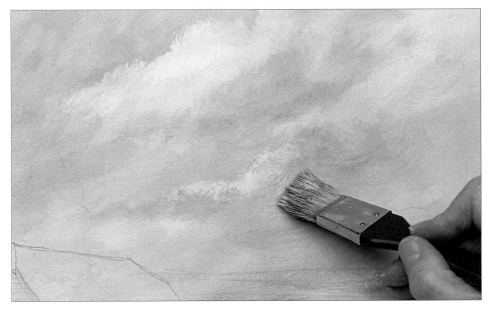

3. Still using the golden leaf brush, touch in a deeper mix of cobalt blue and burnt sienna, wet-in-wet, under the clouds and blend into the lighter colour for a soft edge.

4. Using the same brush, put in the tones for the far distance. Start with a mix of cobalt blue with a touch of white, blending in a little raw sienna to make it less blue towards the foreground, and ending with pale olive green.

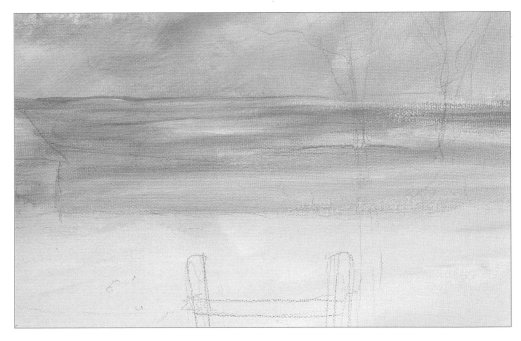

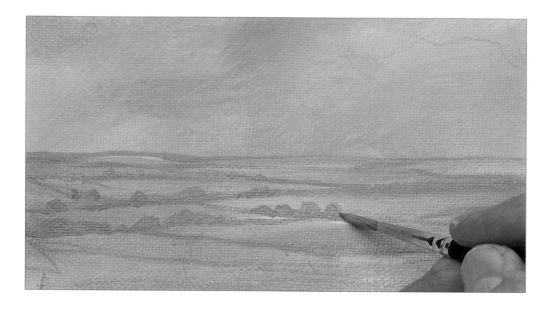

5. Using the point of the small detail brush and a mix of cobalt blue, Hooker's green and white, define the field boundaries right into the far distance. Use a lighter, bluer mix first, adding more green as you work forward to strengthen the colour and bring the hedgerows closer. Paint in the trees by dabbing with the brush so they seem to 'sit' on the boundaries.

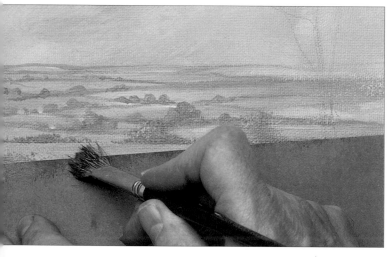

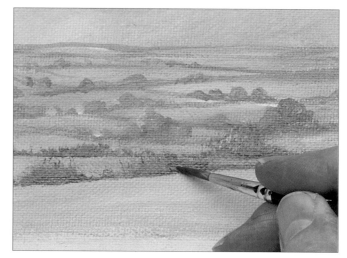

6. Using the edge of a piece of paper and the deerfoot stippler, create the nearer hedgerows. Use the same paint mix, but strengthen it as you come forward by using less white.

7. Using the small detail brush and a deeper mix of cobalt blue and Hooker's green, add shadow under the hedgerow.

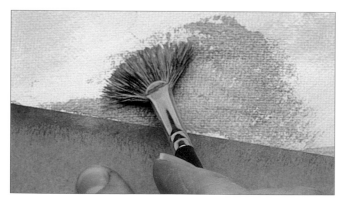

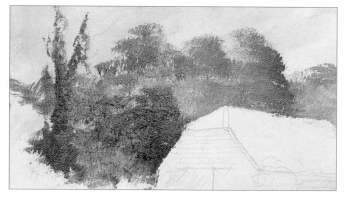

8. Mask the roof area of the barn with a piece of paper. Using the fan stippler and a mix of Hooker's green, cobalt blue and yellow ochre, stipple on the foliage.

9. Add more trees using different mixes of the same colours. Use a dark mix of Hooker's green and ultramarine towards the front for contrast. Turn the brush vertically and add the tree with ivy using a mix of burnt umber and Hooker's green.

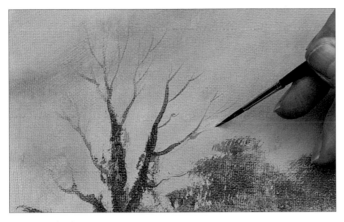

10. Using the half rigger, and still using the mix of burnt umber and Hooker's green, add the small branches and twigs to the ivy-clad tree on the left.

11. Using the fan stippler and a range of green tones, stipple in some foreground foliage. Using a mix of pale olive green, Hooker's green and burnt umber, stipple in the foliage canopy of the tree.

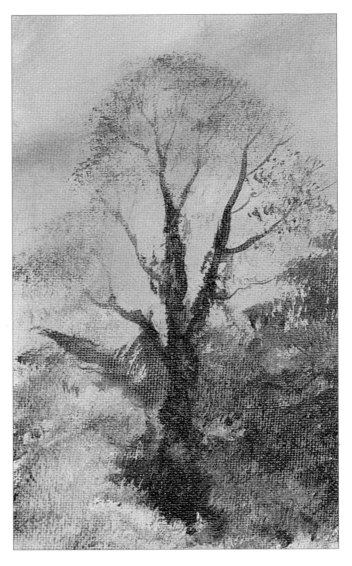

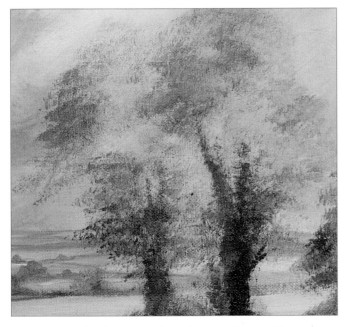

12. Using the fan stippler almost dry, add two more trees with ivy on the right of the picture with a mix of Hookers green and burnt umber. Use mixes of Hooker's green, burnt umber and pale olive green to vary the tones of the foliage.

13. Using the small detail brush and a mix of Hooker's green and burnt umber, put in the branches of the trees.

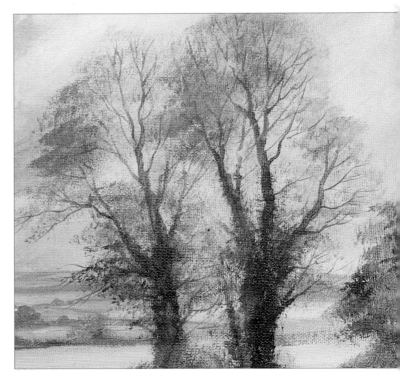

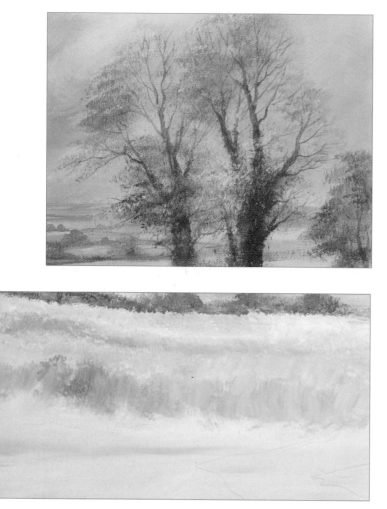

14. Using the fan stippler and a mix of white and pale olive green, stipple in paler foliage all over the trees.

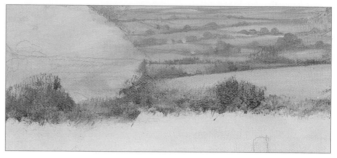

15. Using the fan stippler and a mix of raw sienna and Hooker's green, put in the edge of the cornfield with a dabbing motion, turning the brush sideways to dab in the grasses.

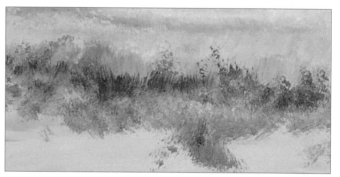

16. Using the golden leaf and a yellow ochre and white mix, varying the tones and dabbing to avoid a flat look, put in the cornfield textures. Vary the effects by stippling in a mix of raw sienna and white, dragging the brush down in places.

17. Using the golden leaf and a mix of Hooker's green and burnt sienna, flick up to produce the effect of grass in the foreground. Add in touches of burnt sienna and pale olive green.

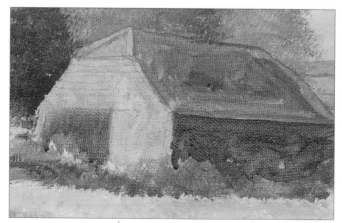

18. Still with the same brush, add the path in the foreground with a mix of white and raw sienna. Finish the foreground grasses using the same colours as before.

19. Using the large detail, establish the tones of the barn. Use a mix of Hooker's green and burnt umber for the side wall and opening and a mix of raw and burnt sienna for the roof, with touches of burnt umber for the shading. For the front wall, use a mix of yellow ochre and pale olive green.

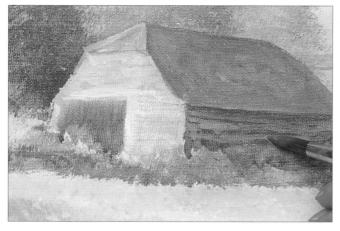

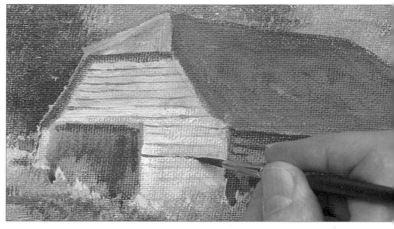

20. Using the large detail brush, start to build up the layers of paint on the barn, using the same colour mixes plus white to make it more opaque. Keep it fairly rough for a rustic look. Put in a few horizontal strokes for the weatherboards with a mix of Hooker's green and burnt umber.

21. Using the small detail brush and a mix of ultramarine and burnt umber, put in the shadow under the eaves and on the front of the barn. Using the same colour mix, put in the dark lines of the weatherboarding.

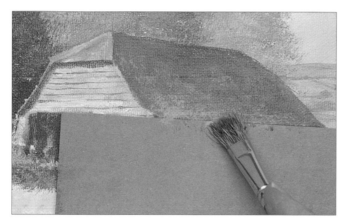

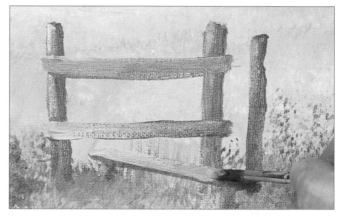

22. Mask the barn with scrap paper and, using the foliage brush, stipple in texture on the roof. Use burnt umber, then a lighter mix of raw and burnt sienna and white.

23. Using the medium detail brush and a mix of burnt umber and Hooker's green, put in the stile. Add highlights using the same brush and a mix of pale olive green and white.

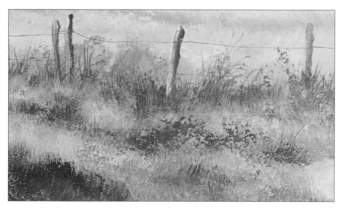

24. Paint in the fence posts using the same brush and mixes of colours as for the stile. Using the half-rigger, add the fence wire.

25. Using the small detail brush and cadmium red straight from the tube, paint the poppies. Touch in a mix of white and cadmium red for a subtle effect, then use the point of the brush to put in a dot of burnt umber and ultramarine in the centre of some of the flowers.

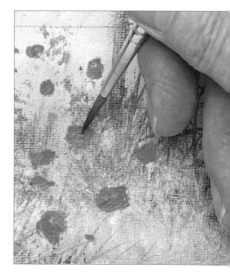

113

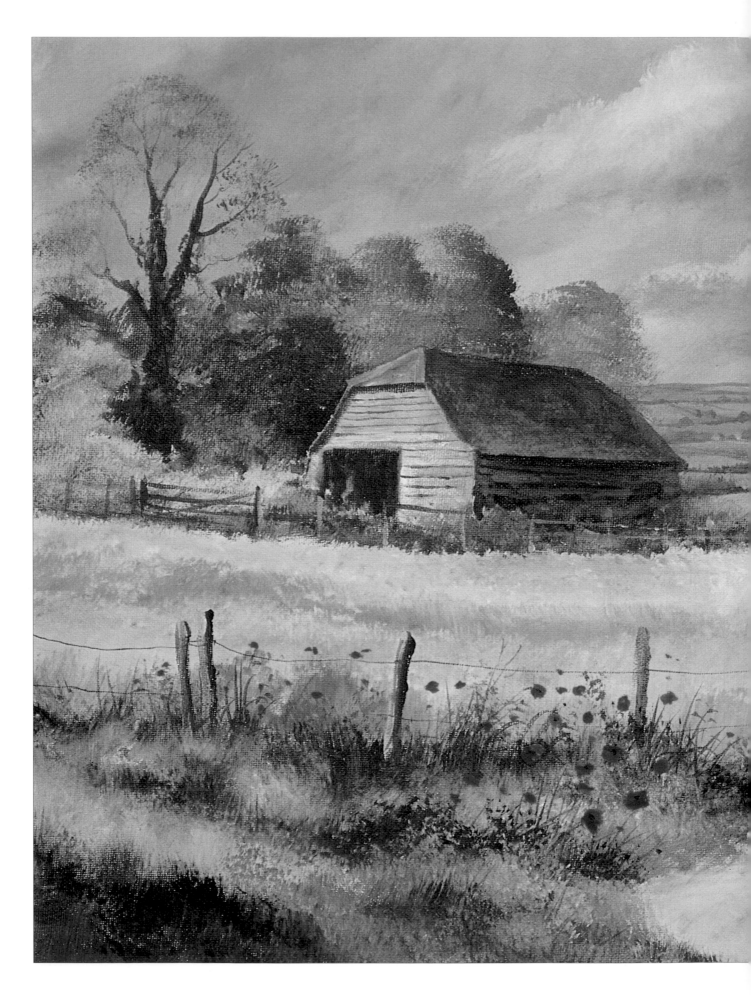

The finished painting

A few more poppies were added to the edge of the field to achieve the desired balance. The area under the stile was darkened slightly using mixes of the same colours with a little ultramarine and burnt umber added.

115

Beachside Taverna

The gnarled olive tree provides a dramatic frame for the scene beyond. The tree was painted using the large detail brush and mixes of Hooker's green and burnt umber. The far hills were painted in blue tones to create recession. Detail brushes were used extensively for the boats, building and the busy beach scene. The flowers in the foreground were put in using the same techniques as for the poppies in the previous demonstration.

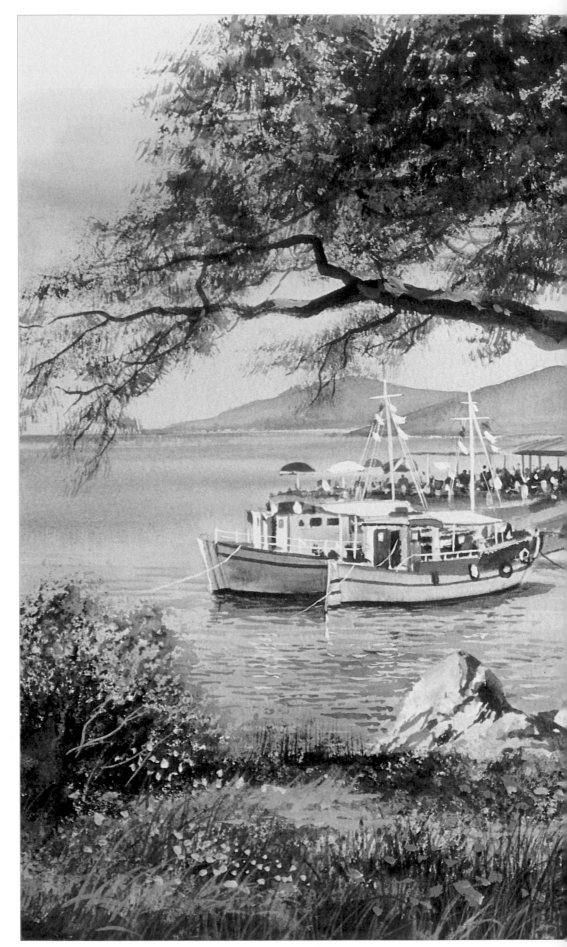

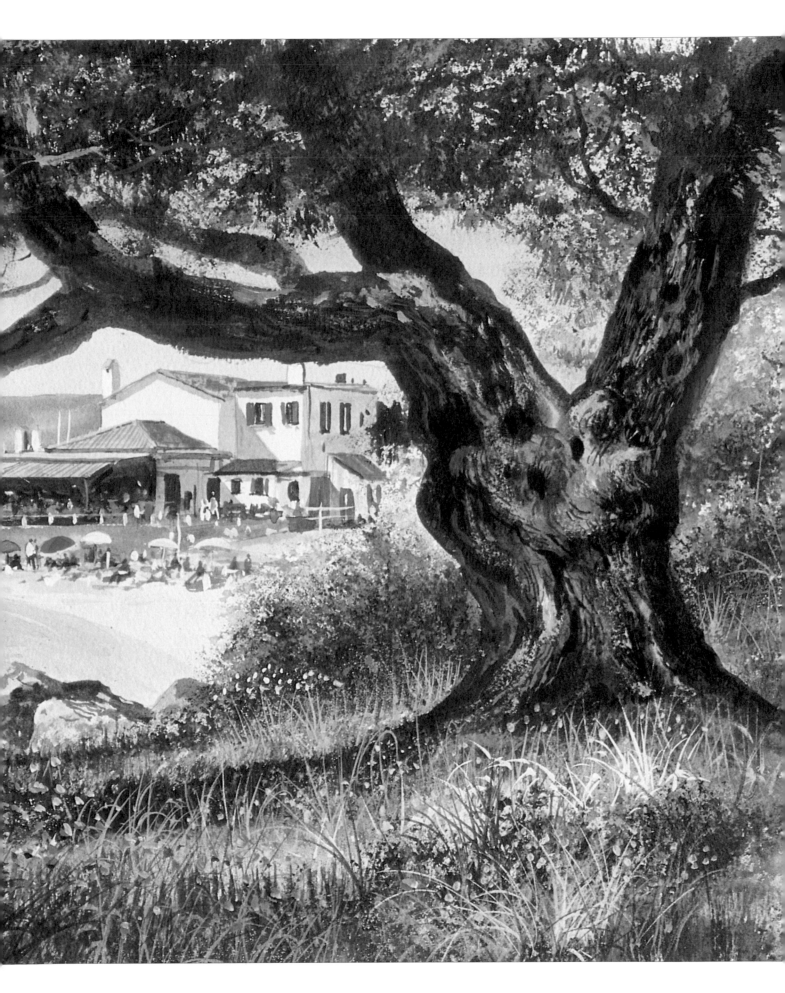

Autumn Woods

This project was worked on canvas board. Even though it is an autumn scene, there is a still fair amount of green in the foliage. When painting foliage, remember that when you put the trunks into what seems to be a random mess, it pulls the whole painting together.

Reflections are a big part of this demonstration and I have painted them in some detail. Don't be intimidated by the thought of adding reflections: just make sure there is something to reflect. Then use the same colours as for the painting but make the mixes slightly lighter. Adding ripples is an obvious visual clue to the water! Use short, dabbing brush strokes for reflections so you get a broken effect.

You will need

Canvas board 53 x 40cm (21 x 16in)

2B pencil

Brushes: golden leaf; small, medium and large detail; foliage; fan stippler; flat brush

Paint: my basic palette (see page 14)

1. Paint in a wash of burnt sienna all over the surface, then draw in the outlines of the lake and trees.

2. Using the golden leaf brush and a mix of cobalt blue and white, dab in the sky area.

3. Add alizarin crimson and white to the mix and paint the misty trees in the background.

4. Using the golden leaf brush and mixes of yellow ochre, white, pale olive and Hooker's green, add the tones for the foliage on the bank. Add the bank using a mix of burnt umber and ultramarine. Drag reflections into the water.

5. Using the golden leaf brush, start to stipple in the foliage with mixes made from various tones and strengths of cadmium yellow, cadmium red and white.

6. Continue to build up the foliage by stippling with a stronger mix of cadmium yellow, cadmium red and a touch of white. Add the ivy-clad tree using a mix of Hooker's green and burnt umber.

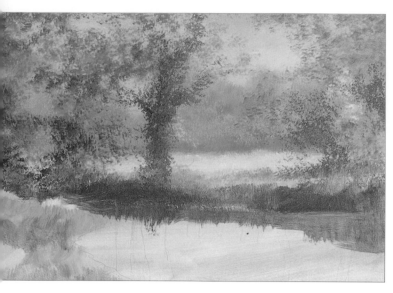

7. Using the large detail brush and a mix of burnt umber and Hooker's green, put in the branches of the tree with ivy and the trunks and branches of the remaining trees.

8. Still using the large detail brush, add another tree in varying tones of burnt umber and Hooker's green. Add tones and highlights on the sunlit side using a small detail brush and a mix of pale olive green, yellow ochre and a bit of white.

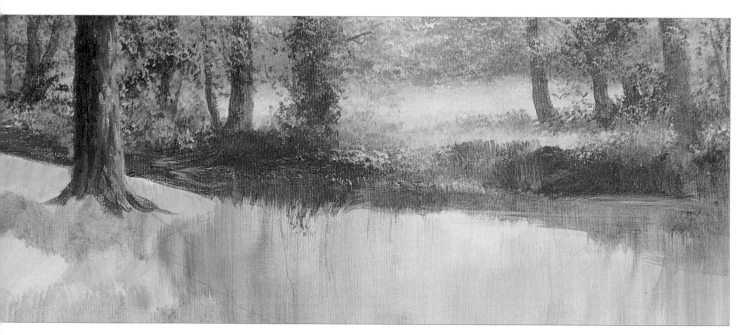

9. Put a wash of white and cobalt blue into the water area, using downward strokes of the golden leaf brush. While it is still wet, put in some cadmium yellow, cadmium red and white to produce a streaked effect.

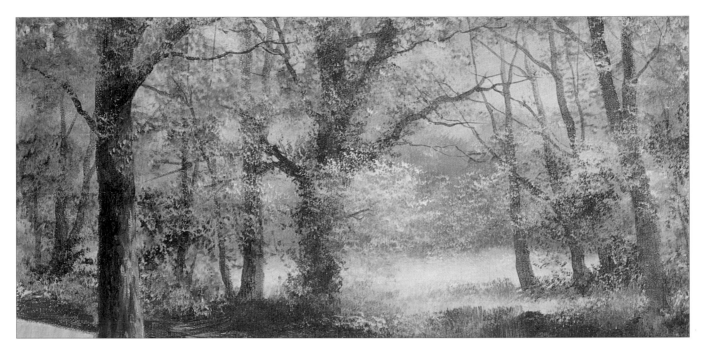

10. Using the golden leaf brush, stipple on some more foliage with mixes of cadmium yellow, cadmium red and burnt sienna, darker tones of burnt umber and burnt sienna, and subtle tones of raw sienna. Begin to add small branches using the half-rigger and a mix of burnt umber and ultramarine.

11. Using the same colours as for the foliage above, draw down the golden leaf to create the reflections. Leave a gap where the sky is reflected in the water. Darken the bank and put in a matching reflection.

12. Using the half-rigger and a mix of burnt umber and ultramarine, put in more small branches to define the foliage.

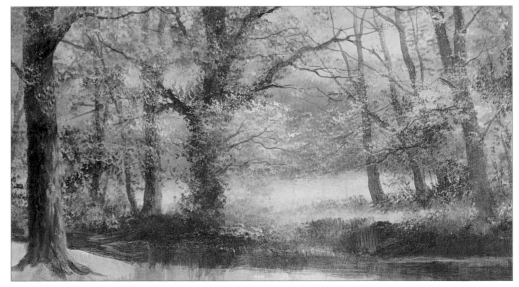

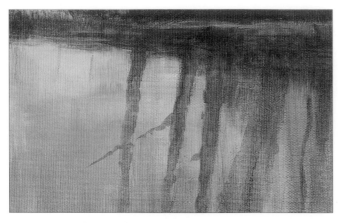

13. Using the medium detail brush and a mix of Hooker's green and burnt umber, put in the reflections of the tree trunks in the water.

14. Using the same colours and tones, drag down the reflections of the trees on the left.

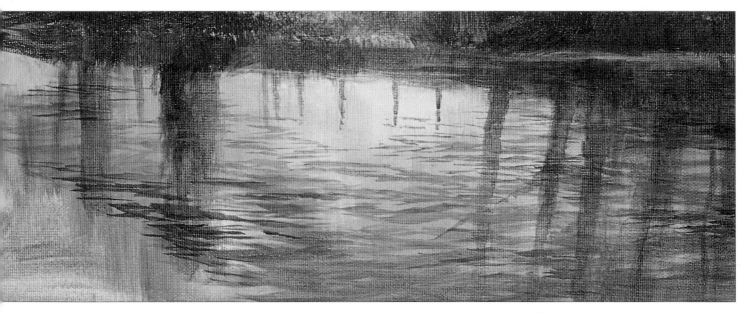

15. Using the medium detail brush, add the reflections of the fence posts. Using the flat brush, start to paint ripples on the water with a mix of burnt umber and Hooker's green, another of cadmium red and cadmium yellow, and a third of cobalt blue with alizarin crimson and a touch of white.

Tip

An easy way to make sure the fence posts and their reflections in the water look accurate is to use the shaft of a brush. Hold it horizontally against the surface to help to line up each reflection as you paint it in.

16. Using the flat brush, add some bright reflections of the autumnal shades above to the water. Use mixes of cadmium yellow and cadmium red, another of cadmium yellow and white, and another of cobalt blue with just a touch of white.

17. Using the foliage brush, start to work on the foreground bank. Begin at the far edge with a light mix of yellow ochre and white, making downward strokes, then add some darker tones with pale olive green. Darken the area under the tree by dabbing in a mix of burnt umber and burnt sienna to produce a shadow effect.

18. Using the flat brush, add ripples in autumn tones, and in cobalt blue and white. Paint the bank using the foliage brush and a mix of yellow ochre and white. Add darker tones using a mix of alizarin crimson and burnt umber. Using the golden leaf, stipple in autumn colours to add texture and tie in with the foliage. Flick grasses over the water's edge using the golden leaf and white mixed with a little yellow ochre.

The finished painting
I completed the painting by working over all the reflections with the flat brush, adding ripples with autumn tones, plus some white and cobalt blue over the top and under the bank. I then worked over the whole painting, sharpening up detail and enhancing areas until I was happy with the overall effect. This is what is known in the art world as 'fiddling'.

The Way Through the Woods
This picture uses a similar palette to the previous demonstration.
The dappled sunlight tones down the expanse of road.

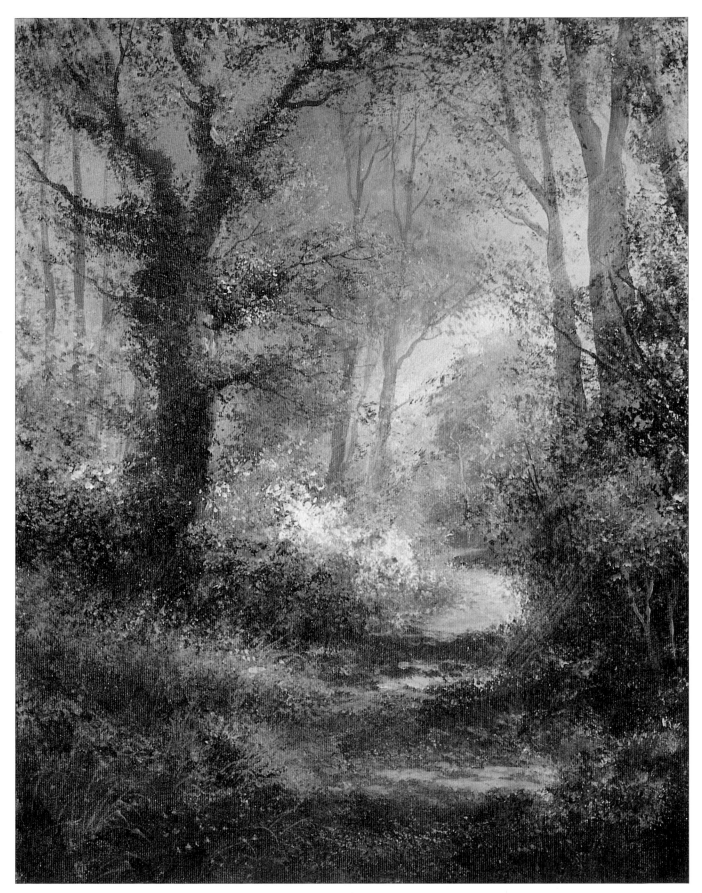

Deep in the Forest

The autumn tones of this scene are lost in twilight except
where a shaft of sunlight illuminates the leaves beneath.

Index